STREET SCENE

How to Draw Graffiti-Style

JOHN LEE

IMPACT
CINCINNATI, OHIO
www.impact-books.com

Street Scene: How to Draw Graffiti-Style. Copyright © 2007 by John Lee. Manufactured in China. All rights reserved. No part of this book may be reproduced in any form or by any electronic or mechanical means including information storage and retrieval systems without permission in writing

from the publisher, except by a reviewer who may quote brief passages in a review. Published by IMPACT Books, an imprint of F+W Publications, Inc., 4700 East Galbraith Road, Cincinnati, Ohio, 45236. (800) 289-0963. First Edition.

Other fine IMPACT Books are available from your local bookstore, art supply store or direct from the publisher.

11 10 09 08 5 4 3 2

DISTRIBUTED IN CANADA BY FRASER DIRECT
100 Armstrong Avenue
Georgetown, ON, Canada L7G 5S4
Tel: (905) 877-4411

DISTRIBUTED IN THE U.K. AND EUROPE BY DAVID & CHARLES
Brunel House, Newton Abbot, Devon, TQ12 4PU, England
Tel: (+44) 1626 323200, Fax: (+44) 1626 323319
Email: mail@davidandcharles.co.uk

DISTRIBUTED IN AUSTRALIA BY CAPRICORN LINK
P.O. Box 704, S. Windsor NSW, 2756 Australia
Tel: (02) 4577-3555

Library of Congress Cataloging in Publication Data
Lee, John
 Street scene : how to draw graffiti-style / John Lee.
 p. cm.
 ISBN-13: 978-1-58180-847-6 (pbk. : alk. paper)
 ISBN-10: 1-58180-847-X (pbk. : alk. paper)
 1. Human figure in art. 2. Popular culture in art. 3. Drawing--Technique. 4. Street art--Technique. I. Title.
 NC765.L38 2007
 741.2--dc22 2006027904

Edited by Mona Michael
Designed by Wendy Dunning
Production coordinated by Jennifer Wagner

METRIC CONVERSION CHART

To convert	to	multiply by
Inches	Centimeters	2.54
Centimeters	Inches	0.4
Feet	Centimeters	30.5
Centimeters	Feet	0.03
Yards	Meters	0.9
Meters	Yards	1.1

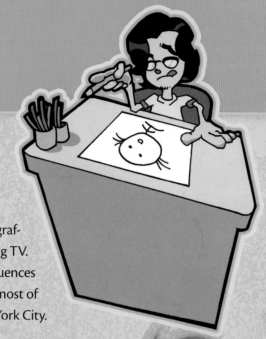

About the Author

John Lee is an illustrator specializing in a variety of areas, including and not limited to cartoons, character design, monkeys, humor, people, toys, games, graffiti, anime, sleeping, eating and watching TV. His Eastern origins and his Western influences combine to serve as his inspiration for most of his works. He currently resides in New York City.

Acknowledgments

I'd like to say thanks to my wonderful editors at IMPACT Books, Mona Michael and Pam Wissman. They couldn't have been nicer and more helpful in assisting me with the creation of this book which, without them, wouldn't have been possible.

Dedication

I am going to keep this short and sweet: I'd like to thank my friends and family and everyone on this lovely planet.

CONTENTS

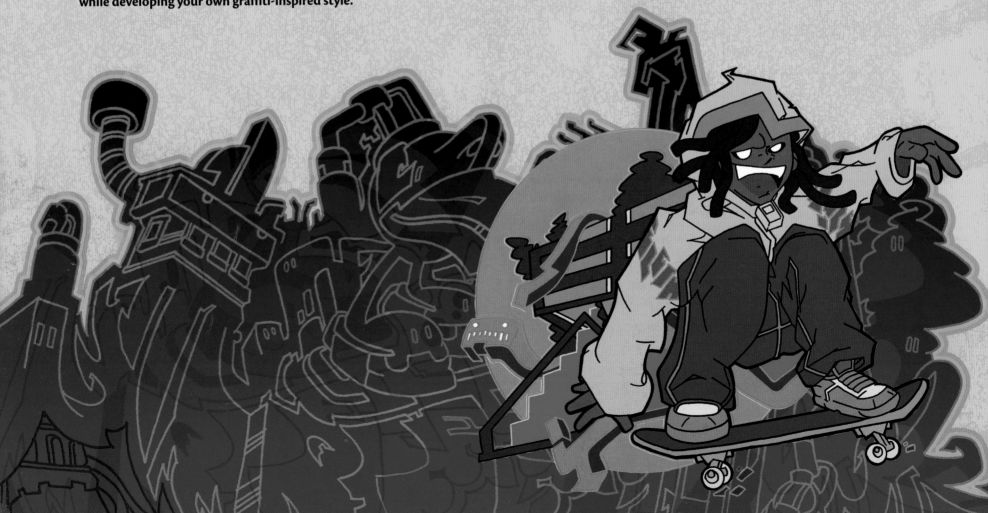

Here you'll apply everything you've learned so far to create as many types of characters as you can imagine. Don't forget to make up your own!

Learn how to put together easy shapes, lines and colors to make ultracool backgrounds and scenes.

WHAT TO DRAW?

Next time you go out with your friends, remind yourself to observe what is around you and store it in your memory bank. This will give you ready references. In the pages to follow you'll learn how to take those references of the people, things and backgrounds that surround you and turn them into art. You'll learn to draw what is essential and to take out what isn't to form effective and powerful works of art.

IN THE PAGES TO FOLLOW YOU'LL LEARN TO MAKE SKETCHES OF PEOPLE WITH DIFFERENT CHARACTERISTICS...

...THEN HOW TO GIVE THEM SOME COLOR.

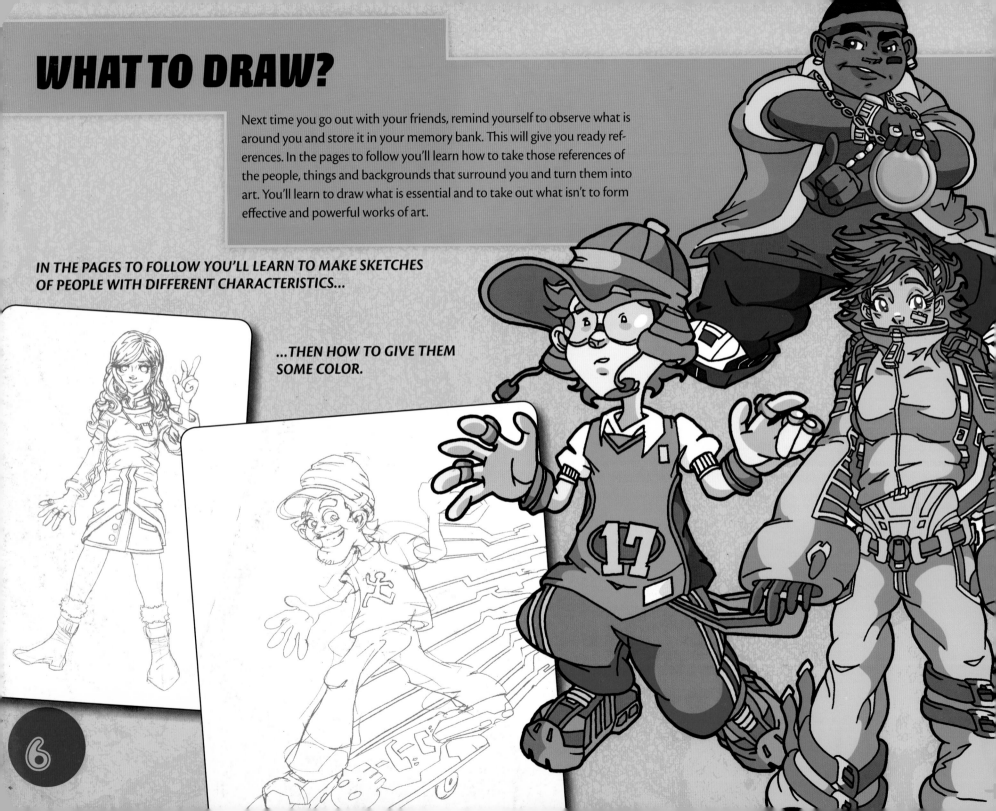

6

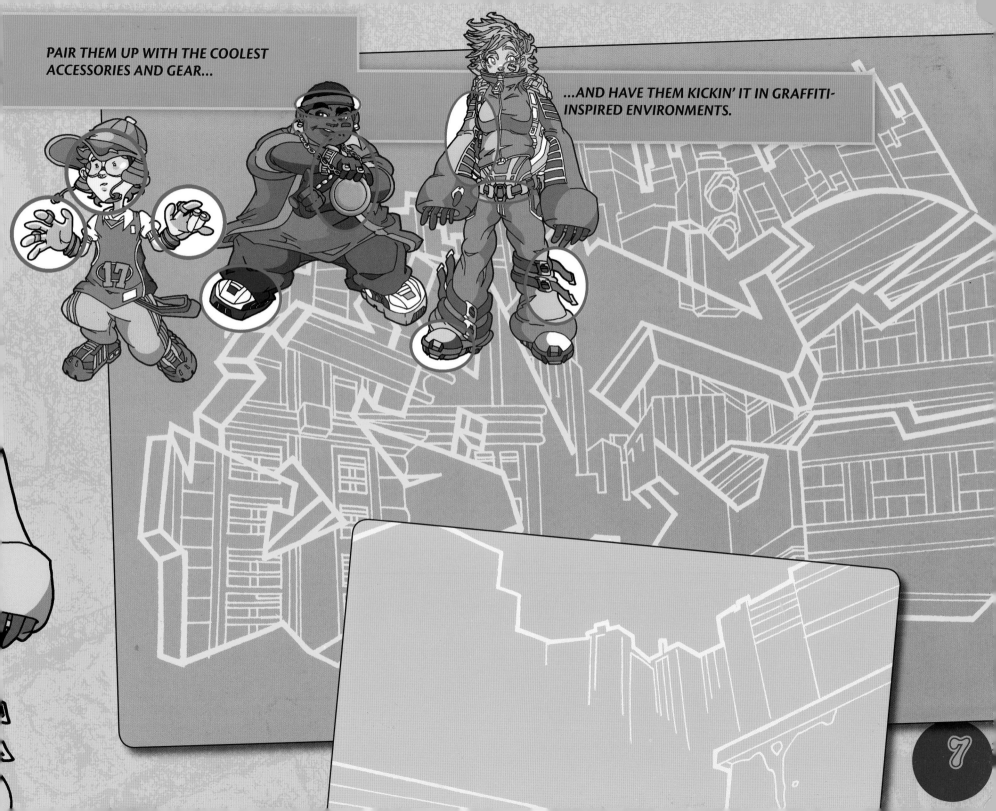

PAIR THEM UP WITH THE COOLEST ACCESSORIES AND GEAR...

...AND HAVE THEM KICKIN' IT IN GRAFFITI-INSPIRED ENVIRONMENTS.

17

7

GETTING STARTED

SUPPLIES

Before you start to draw, let's go over some of the supplies you should have on hand.

PENCILS

Whether you use regular hard-lead pencils or mechanical varieties, different leads are categorized by their degree of hardness. The range goes from (H) hardest to (B) softest with (HB) in the middle. The B leads are usually used for preliminary sketches because the softness of the lead allows for more looseness and fluidity. The hard H leads are used more for finishing up and creating precise lines to straighten up initial sketches.

ERASERS

You can find erasers in big plastic molds for bigger jobs and also enclosed in a pen-click form for more small and precise erasures.

PAPER

Slightly textured papers are better for drawing in pencil and smoother papers are ideal for ink drawings. Regular copy paper will do the job for practice because it works for both pencil and ink outlines. It also doesn't hurt that this type of paper is fairly inexpensive and readily available in most stores.

INKING PENS AND BRUSHES

Ink can be applied with brushes, metal nib pens or technical inking pens or markers that have tips in varying widths. Brushes and metal nib pens are dipped into waterproof India ink; technical pens have a built-in ink supply so no dipping is required.

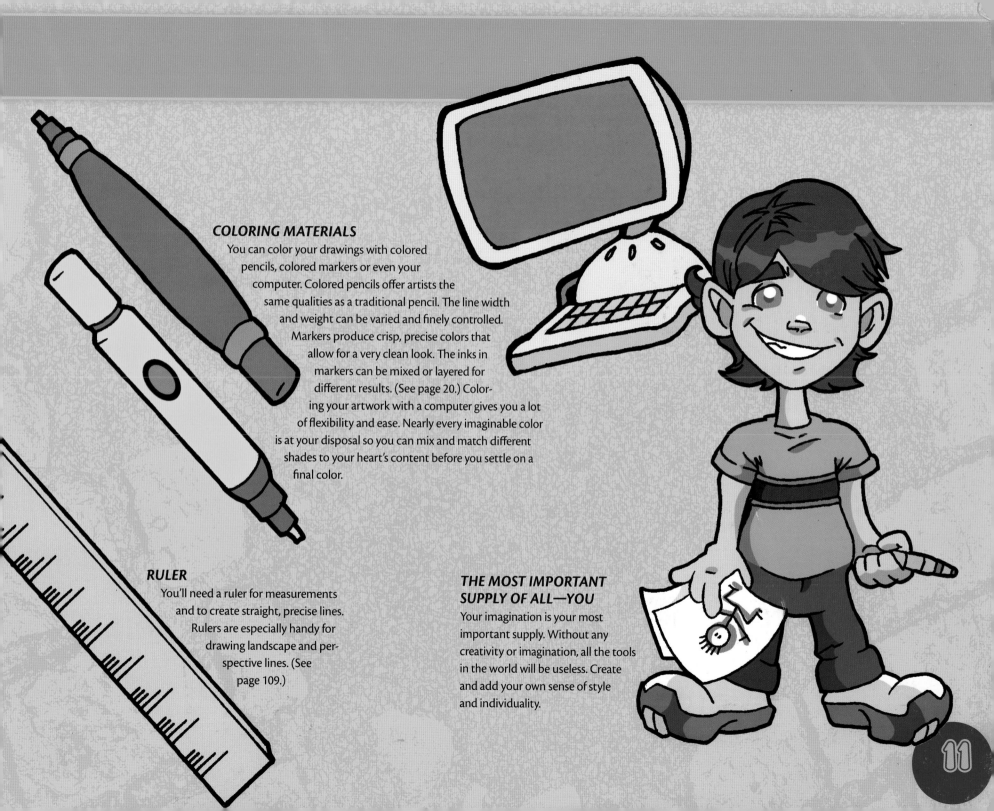

COLORING MATERIALS

You can color your drawings with colored pencils, colored markers or even your computer. Colored pencils offer artists the same qualities as a traditional pencil. The line width and weight can be varied and finely controlled. Markers produce crisp, precise colors that allow for a very clean look. The inks in markers can be mixed or layered for different results. (See page 20.) Coloring your artwork with a computer gives you a lot of flexibility and ease. Nearly every imaginable color is at your disposal so you can mix and match different shades to your heart's content before you settle on a final color.

RULER

You'll need a ruler for measurements and to create straight, precise lines. Rulers are especially handy for drawing landscape and per-spective lines. (See page 109.)

THE MOST IMPORTANT SUPPLY OF ALL—YOU

Your imagination is your most important supply. Without any creativity or imagination, all the tools in the world will be useless. Create and add your own sense of style and individuality.

11

WHAT'S IN A STYLE?

So what is "graffiti-style" anyway? Let's start by discussing what we mean by *style*. I describe my style as a melding of manga and old-school American animation with a dab of street graffiti mixed in. It's an open term, because style is what you make of it...how thick you create a line, what kinds of colors you use and even your personality. That's really all "graffiti-style" is. It's how you express yourself.

There are, however, some basic styles we are all familiar with, such as a very realistic style or a very "cartoony" style.

What is crucial for any style is a good understanding of drawing technique, because that will give you a good foundation. All styles of faces, for example, have general face characteristics: two eyes, one nose, two ears, etc.

NO ONE WANTS TO BE A ROBOT

Robots might be cool to draw or look at, but it isn't cool to be one. Don't draw like you are taking a test. Let yourself make mistakes. All artists make mistakes because we are *not* robots. What makes art great is that no two artists are alike.

TRADITIONAL COMICS STYLE

MY STYLE
I combine the traditional comics style with a bit of manga and graffiti inspiration to get this look.

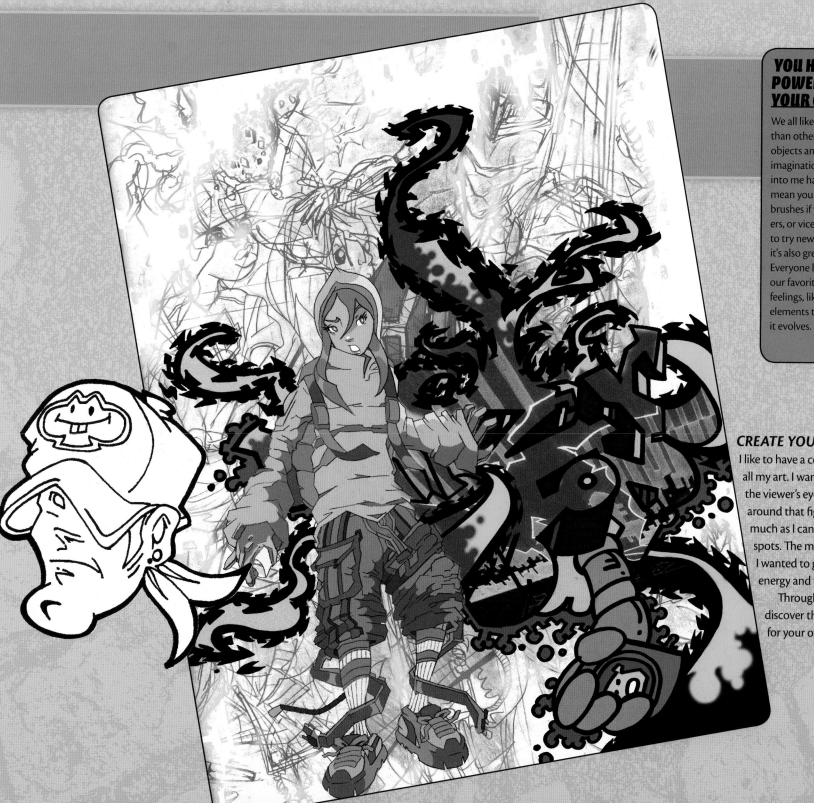

YOU HAVE THE POWER TO CREATE YOUR OWN STYLE

We all like drawing some things more than others. I like drawing whimsical objects and characters mostly from my imagination because it just translates into me having more fun. That doesn't mean you should never paint with brushes if you like coloring with markers, or vice versa. It just means it's fun to try new and different things, but it's also great to have some favorites. Everyone loves to eat, but we all have our favorite foods also. Go with it. Your feelings, likes and dislikes all become elements that go into your style as it evolves.

CREATE YOUR OWN METHOD

I like to have a central character in almost all my art. I want that character to draw the viewer's eye first. Then, I like to build around that figure, filling in details as much as I can so there aren't many empty spots. The most important concept I wanted to get across in this piece was energy and fun.

Through time and practice, you'll discover the method that works best for your own style.

13

DRAWINGS BEGIN WITH SHAPES

Everything you see can be divided into different shapes. Think about it—the car on the street is made up of a rectangle and four circles. The MP3 player you're listening to consists of simple circles and squares. Even the human body is just a series of cylinders.

**BASIC SHAPES OCCUR IN ANYTHING
YOU WANT TO DRAW**

SHADING THE SHAPES GIVES THEM FORM

**SHAPE AND FORM
MAKE UP PEOPLE...**

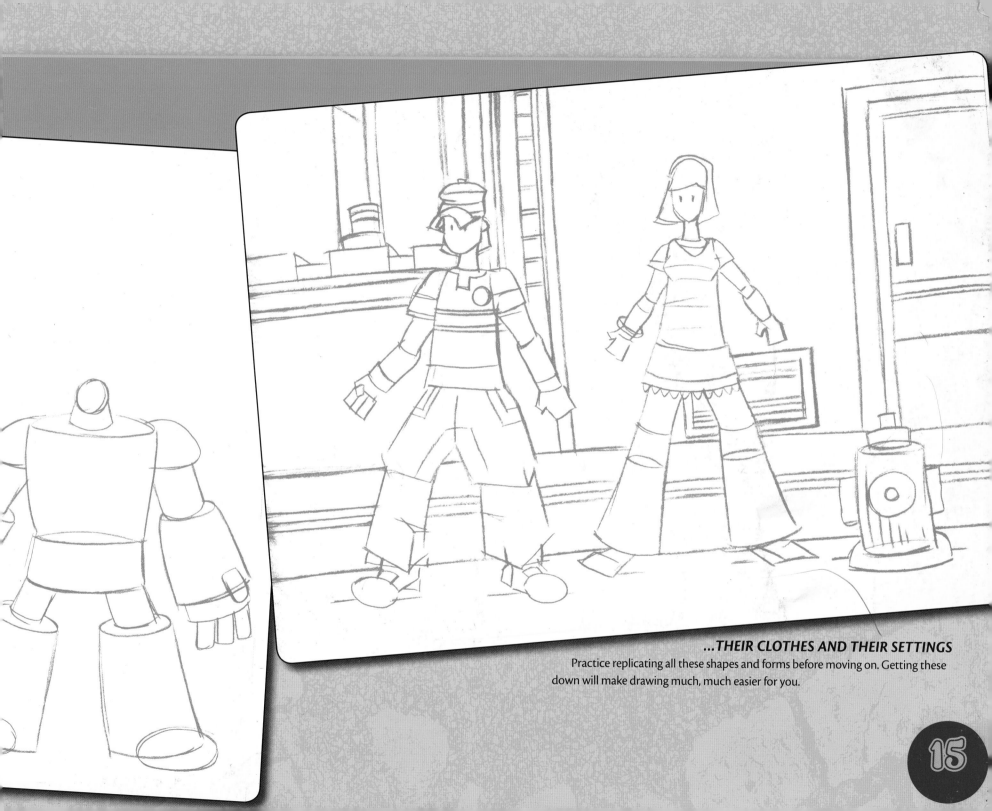

...THEIR CLOTHES AND THEIR SETTINGS

Practice replicating all these shapes and forms before moving on. Getting these down will make drawing much, much easier for you.

GESTURE SKETCHES SHOW POSE AND MOVEMENT

Sketching is like a pre-draft to the final picture or an outline you write when you begin an essay. The first thing you do when writing a paper is outline your beginning, middle and end. In drawing, it's best to begin with a gesture sketch to figure out the pose and movement of your figure.

It's a lot easier to plan out what you want your picture to look like beforehand, rather than going into it blind. For example, if you want a running figure, how is he going to run? Is he jogging leisurely or running fast?

BEGIN WITH GESTURES

Create gesture drawings with stick figures and simple shapes before you begin any drawing.

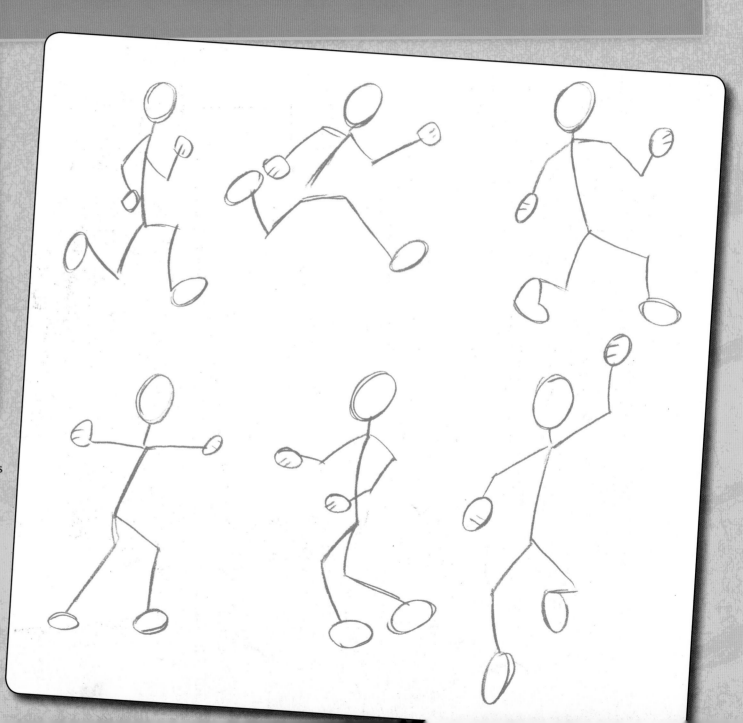

TURN YOUR SHAPES INTO SKETCHES

After you've worked out some gesture sketches and stick figures, it's time to decide what details you want so you won't have any guessing to do in the finishing stages. The first and pretty much only rule to remember in sketching is that there are no rules. There's no right or wrong way. Sketches shouldn't be perfect. Just get an idea of what you want to draw so you can explore that idea as you go along.

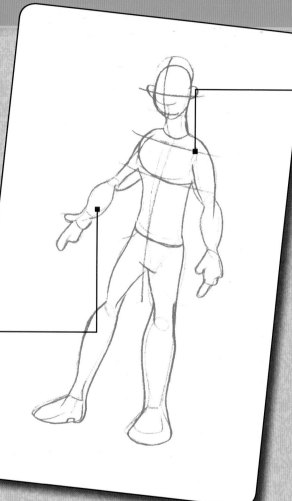

DRAW GUIDELINES FOR YOUR FIGURE TO REMIND YOU TO DRAW THE SAME FEATURES ON BOTH SIDES OF THE BODY.

DRAW DIMENSIONAL LINES BASED ON YOUR GESTURE SKETCH AND BASIC SHAPES. BUILD THE DEFINITION OF THE LOWER AND UPPER ARMS BASED ON CYLINDER SHAPES.

BEGIN SKETCHING
Draw a standard figure, nothing fancy. Then put him in some different poses.

SKETCHING PENCILS

Light blue, non-reproducing pencils don't reproduce in copiers. So, when you sketch your picture in blue then tighten it up with graphite, only your clean lines will show. It's an effective method to prevent a lot of erasure marks showing up in your finished work.

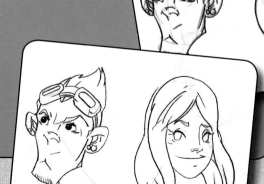

WORK OUT THE DETAILS

You might need to draw several sketches of a certain character to decide what you want to keep and what you want to delete. Drawing several sketches of the same subject allows you to become more familiar with your subject so you won't have any hesitation later on.

ADD SOME LINES
Just a few additional lines help create the look of your picture.

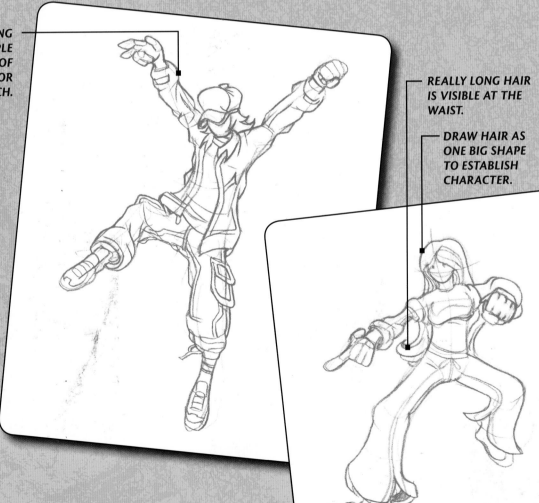

DRAW CLOTHING USING SIMPLE LINES ON TOP OF THE GESTURE OR FIGURE SKETCH.

REALLY LONG HAIR IS VISIBLE AT THE WAIST.

DRAW HAIR AS ONE BIG SHAPE TO ESTABLISH CHARACTER.

OVERSIZED CLOTHING CREATED USING SIMPLE LINES FOR WRINKLES.

AND SHADING TO SHOW THE INSIDES OF CUFFS, SLEEVES, ETC.

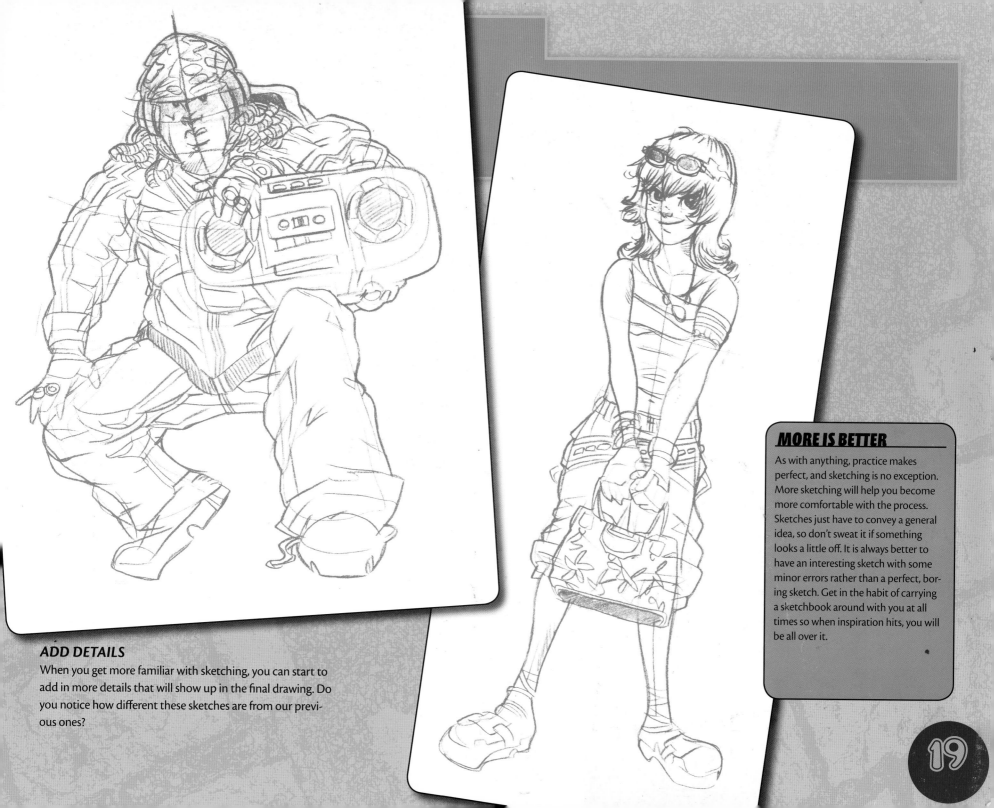

ADD DETAILS

When you get more familiar with sketching, you can start to add in more details that will show up in the final drawing. Do you notice how different these sketches are from our previous ones?

MORE IS BETTER

As with anything, practice makes perfect, and sketching is no exception. More sketching will help you become more comfortable with the process. Sketches just have to convey a general idea, so don't sweat it if something looks a little off. It is always better to have an interesting sketch with some minor errors rather than a perfect, boring sketch. Get in the habit of carrying a sketchbook around with you at all times so when inspiration hits, you will be all over it.

WHAT YOU SHOULD KNOW ABOUT COLOR

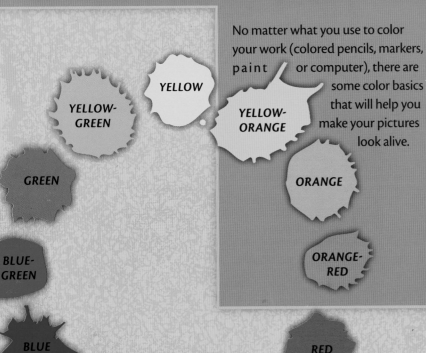

YELLOW

YELLOW-GREEN

YELLOW-ORANGE

GREEN

ORANGE

BLUE-GREEN

ORANGE-RED

BLUE

RED

BLUE-VIOLET

VIOLET

RED-VIOLET

No matter what you use to color your work (colored pencils, markers, paint or computer), there are some color basics that will help you make your pictures look alive.

There are four factors that go into every color:

Hue, which is the actual color.

Temperature is the warmth or coolness of a color. Green, blue and violet are generally considered cool colors while yellow, orange and red are considered warm.

Value is the brightness or darkness of a color. Adding white usually lightens the value of a color while adding black darkens the value.

Intensity measures the vividness or dullness of a color. You can lessen the intensity or dull a color by adding its complement (see the color wheel). For example, to create a dull red, add a little green.

THE COLOR WHEEL
The color wheel shows how colors feed and react off each other. The three main or *primary* colors of the wheel are red, blue and yellow. All the other colors of the wheel are combinations and variations of these three. *Secondary* colors are created when two primary colors are blended together, and *tertiary* colors are made when a primary color and a secondary color are mixed.

USE ALL ASPECTS OF COLOR
Value and intensity will help you create highlights and shadows for dimension. For example, you can make a nice shadow color for a red object by adding either black or red's complement, green. Being aware of hue and temperature will help you create great contrasts and excitement in your work. For example, since the blue singer is made up of very cool colors, she'll immediately stand out in a background of warm yellows or oranges.

20

SHADOWS AND HIGHLIGHTS

Shadows and highlights are both affected by a light source (the sun, a lamp, overhead lights). To create shadows and highlights in your figures, you have to consider your light source and where it is coming from.

When light hits a surface, it creates a reflection. The areas that do not receive light are shrouded in shadows. In areas closer to the light source the colors will be brighter and more intense, while as you go farther away from the light the colors will start to darken and lose intensity.

Show this in your art by making highlights a lighter shade and shadows a darker shade of the original color.

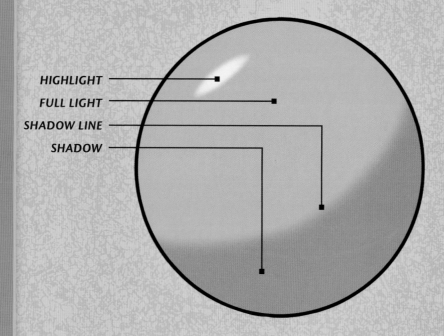

HIGHLIGHT

FULL LIGHT

SHADOW LINE

SHADOW

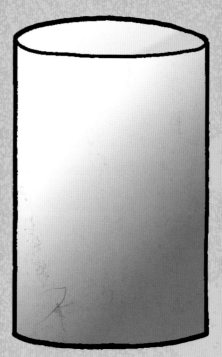

CELL SHADING
For most of the art featured in this book, I've used the more exaggerated shading employed on this sphere. There is more of a clear division between light and dark.

GRADUAL CHANGES
On this cylinder, there is a gradual change from light to dark. This type of shading is common in realistic art.

Highlights and Shadows in Action

Add shadows and reflections where clothes fold and overlap or where the light hits hair and accessories. Note that when light hits a fold or crevice, the top or raised point will become the highlight or full light portion, while the bottom points will become shadow.

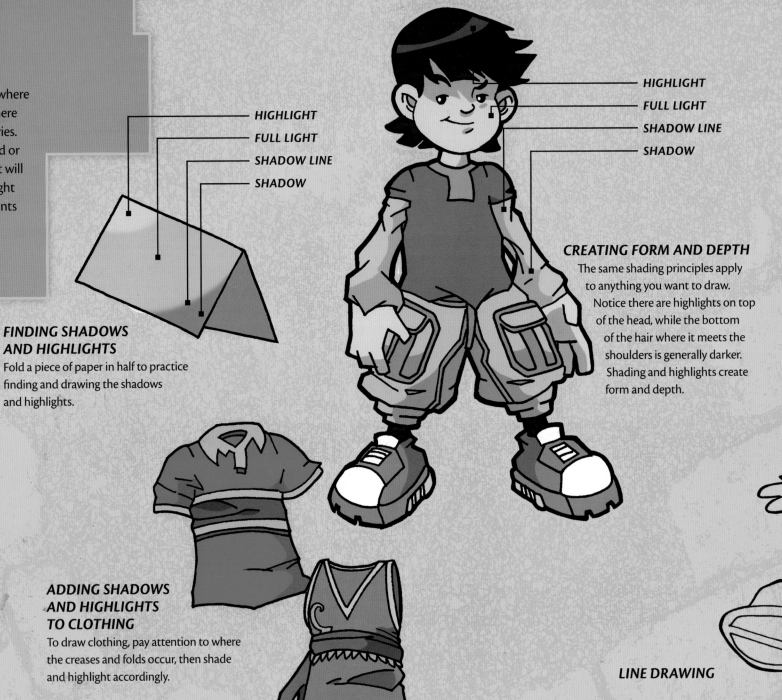

HIGHLIGHT
FULL LIGHT
SHADOW LINE
SHADOW

HIGHLIGHT
FULL LIGHT
SHADOW LINE
SHADOW

FINDING SHADOWS AND HIGHLIGHTS

Fold a piece of paper in half to practice finding and drawing the shadows and highlights.

CREATING FORM AND DEPTH

The same shading principles apply to anything you want to draw. Notice there are highlights on top of the head, while the bottom of the hair where it meets the shoulders is generally darker. Shading and highlights create form and depth.

ADDING SHADOWS AND HIGHLIGHTS TO CLOTHING

To draw clothing, pay attention to where the creases and folds occur, then shade and highlight accordingly.

LINE DRAWING

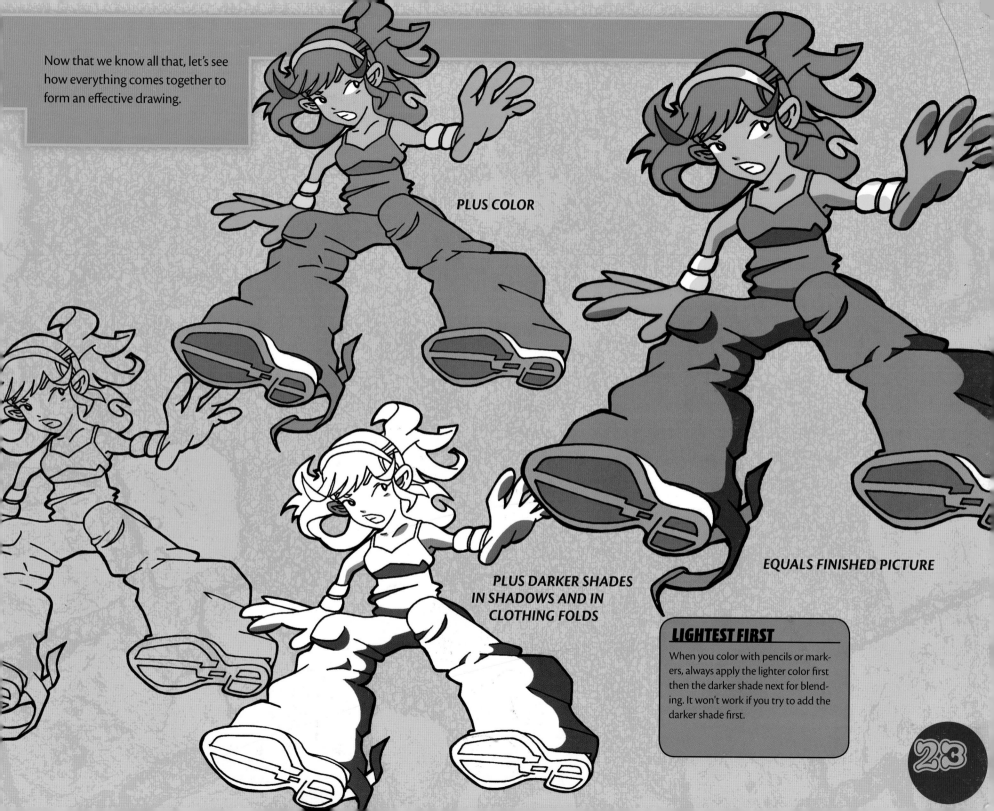

Now that we know all that, let's see how everything comes together to form an effective drawing.

PLUS COLOR

EQUALS FINISHED PICTURE

PLUS DARKER SHADES IN SHADOWS AND IN CLOTHING FOLDS

LIGHTEST FIRST

When you color with pencils or markers, always apply the lighter color first then the darker shade next for blending. It won't work if you try to add the darker shade first.

23

DRAWING PEOPLE
BASICS

Heads

The head is a natural place to begin the figure because it's usually the first thing we look at when we see someone. A person's face can tell us his or her personality and characteristics.

Here are some guidelines for creating the head. Keep these in mind as you begin to create your own characters.

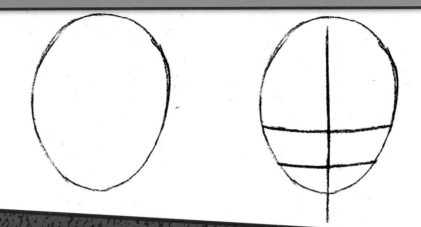

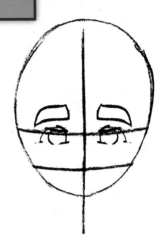

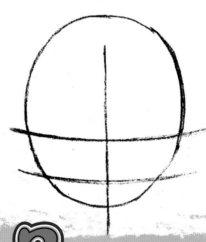

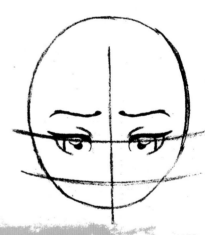

 Begin with a simple oval shape.

Draw two horizontal lines and one vertical line to divide the head into six pieces. Extend the vertical line a little below the oval because that will show you where to put the chin. These are your *guidelines* that will help you place all the different parts of the face.

The upper horizontal line is the *eye line*. Draw the eyes equidistant from where the vertical line intersects with the eye line. Draw eyebrows directly above the eyes.

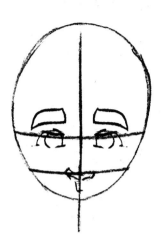

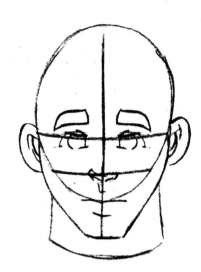

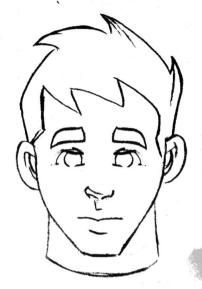

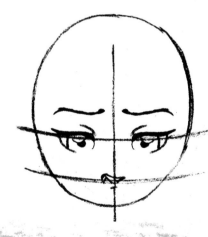

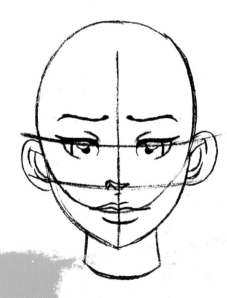

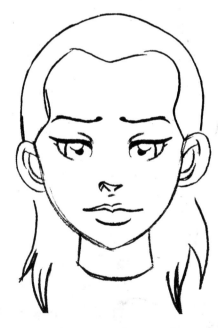

5 Begin the mouth where the bottom tip of the oval meets the vertical line. The mouth placement is directly related to how long you extend the vertical line to draw the chin. Draw the chin where the line stops.

Ears usually spring out from the sides of the eye line and extend down toward the sides of the nose line. The neck drops from the ends of the chin. It's usually wider for males and thinner for females.

6 Add hair as one complete shape. As you refine the drawing you'll add easy lines and shading to complete it.

4 The lower horizontal line is the *nose line*. It indicates where the nose ends. You can tell how long a person's nose is by measuring the eye line down to the nose line.

Heads, Profile

With a profile, since you are only dealing with one side, you only need to draw one eye, one eyebrow, one ear, etc. You are drawing the head shape from a different perspective. The head will still be an oval, but it will flatten out as it meets the neck.

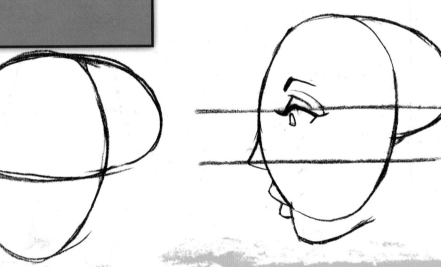 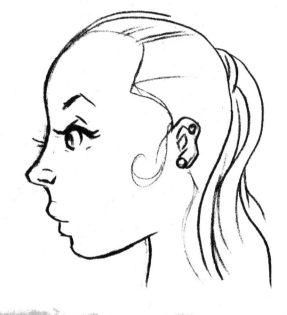

1 Start with an oval as before. To represent the slight bump we all have on the backs of our heads, insert another oval rested on its side at the top.

2 You don't need to draw vertical guidelines since you're only dealing with one side, but you do want the horizontal guidelines to help you place the eyes, nose and mouth.

3 The ear rests slightly past the middle point of the head. From where the second oval lies, begin to draw the neck. The outlines of the lips will sprout out from the side. Draw the nose so that only one nostril is visible.

REC.

Heads, 3/4-View

In a 3/4-view, the head is tilted a little to the side. You're still drawing both sides of the head; however, since it is a 3/4-view, more space and attention is given to whichever side the head is facing.

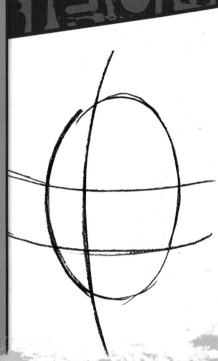

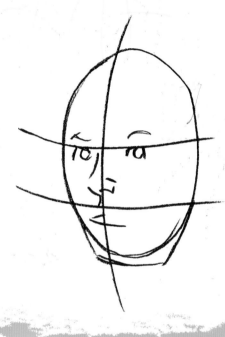

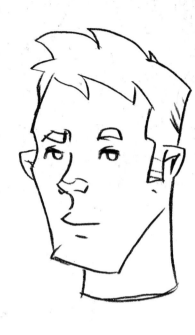

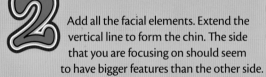

1 Start off with an oval as before and draw horizontal and vertical guidelines. Shift them a little because a 3/4-view means that one-fourth of the face won't be seen.

2 Add all the facial elements. Extend the vertical line to form the chin. The side that you are focusing on should seem to have bigger features than the other side.

3 Put in the ears. They should be more prominent on the side closest to the viewer. Give the same treatment to the neck and hair (one sideburn for guys and one side of the hair parted back for girls).

FACIAL FEATURES

Now that you know how to draw the head, let's go more in-depth on the individual parts of the face.

EYES

Eyes tell us if a person is angry, happy, sad or frightened. Practice drawing these eyes and placing them on your face drawings.

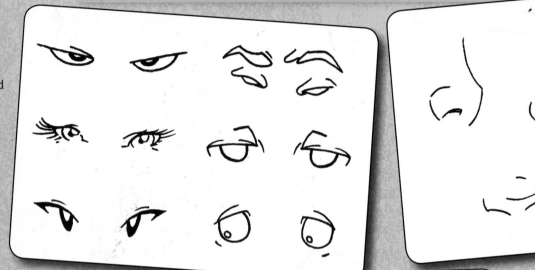

SECONDARY FACIAL FEATURES

Often best represented with simple lines, secondary facial features such as eyebrows can provide characters with that extra bit of personality.

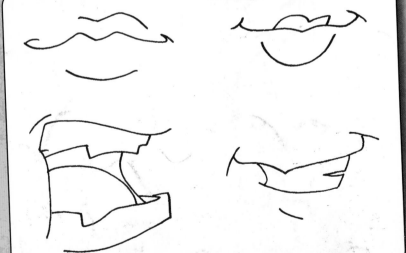

NOSES

The female nose is smaller with somewhat narrow nostrils. Practice drawing these and placing them on your face drawings.

MOUTHS

Like the eyes and the nose, you can exaggerate the mouth to fit your means as long as you make sure your mouths consist of an upper and a lower lip.

HAIR

Hair is a great indicator of who people are. A prim and proper girl might have a very conservative and well-kept haircut while a free spirit will most likely have a wilder style.

It is not necessary to draw every strand of hair; just get a clear idea on a general shape that you want. Hair should look like it is naturally flowing from one part to the next and not just be a big clump on the top of the head.

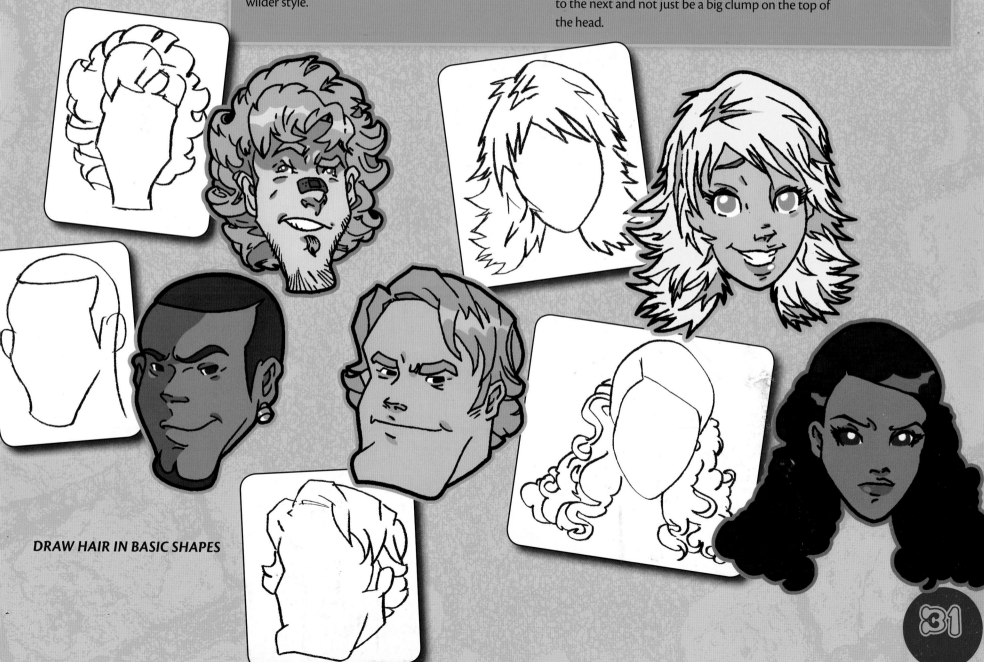

DRAW HAIR IN BASIC SHAPES

PUTTING TOGETHER A FACE

By combining all these elements, you can begin to create faces with different personalities and characteristics by altering or tweaking certain features.

Remember, it is important to create faces that have matching features and characteristics. If you try to mix and match too much, it could come off as looking weird.

MAKE UP YOUR OWN

Practice making up facial features of your own. Play with the sizes of the eyebrows and pupils. Practice making mouths with very few lines. See if you can fill an entire sketchbook page with nothing but faces like these.

MIX AND MATCH

Mix and match the facial features and hair shapes from pages 30 and 31 to create different characters.

DRAWING THE FIGURE

The *gesture drawing*, or stick figure, helps you decide on your pose in the early stages. Simple lines and circles for joints are all you need to work out what body parts are going to be placed where. The next step is to begin to fill out that stick figure into what I call a *bubble figure*. This involves working the basic shape of the figure over the stick figure and beginning to give your character some volume.

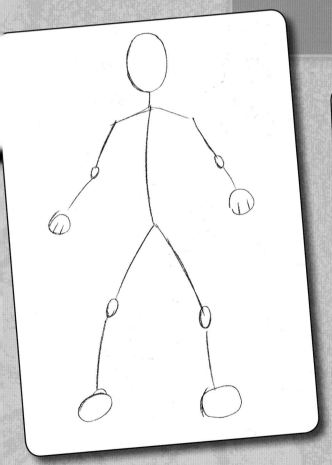

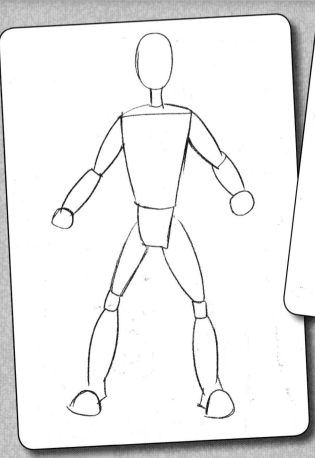

GESTURE DRAWING OR STICK FIGURE
Use this stage to figure out general placements for body parts.

BUBBLE FIGURES
Use basic shapes as a guide to draw the bubble figure over your stick figure. At this point you can decide how large you want your figure to be.

Hands

Hands are great at expressing feelings, like the features of a face. An open hand might suggest apprehension while a closed fist might signify that one is ready for action. At first, hands can be very difficult to draw because of their shapes and varying angles. However, if you break the hand into little pieces and draw it step by step, it becomes much easier.

EMOTIONAL HANDS
All hands begin with the same basic shapes. Can you guess their emotions by their hands?

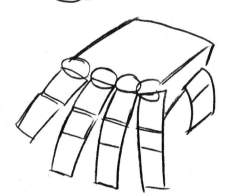

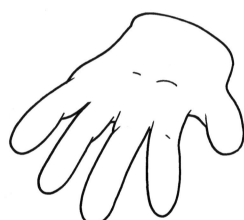

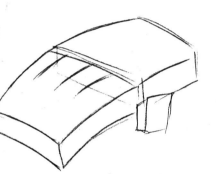

 Start with a simple outline and build gradually outward. Draw the hand in block form.

 Divide that block by drawing in all the joints and knuckles. If you are not sure how many to draw or where it folds and bends, take a look at your own hand. There's no better model than that!

3 Smooth out the forms by rounding the hands and fingers.

Feet

Most of the time, feet are covered by shoes. However, it's still handy to know how to draw the basic foot shape. Much like the hand, it's a tricky thing to draw and is made up of many individual parts.

ONE SHAPE AT A TIME
The foot is made up of shapes, just like everything else.

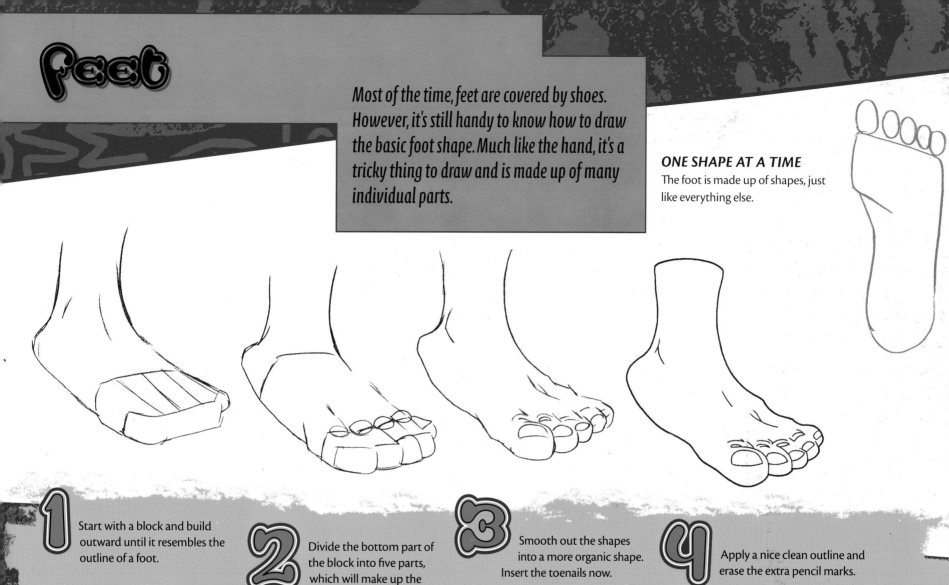

1 Start with a block and build outward until it resembles the outline of a foot.

2 Divide the bottom part of the block into five parts, which will make up the toes. Indicate joints and leave space for toenails.

3 Smooth out the shapes into a more organic shape. Insert the toenails now.

4 Apply a nice clean outline and erase the extra pencil marks.

SHOES

While we're on the subject of feet, let's cover that all-important subject—shoes. Give your characters special care by fitting them with personalized kicks.

SHOES FOR GUYS

Shoes, whether they are classic high-tops, low-tops, boots, running or basketball shoes, come in a million different colors and variations but all share the same essential design elements and shapes.

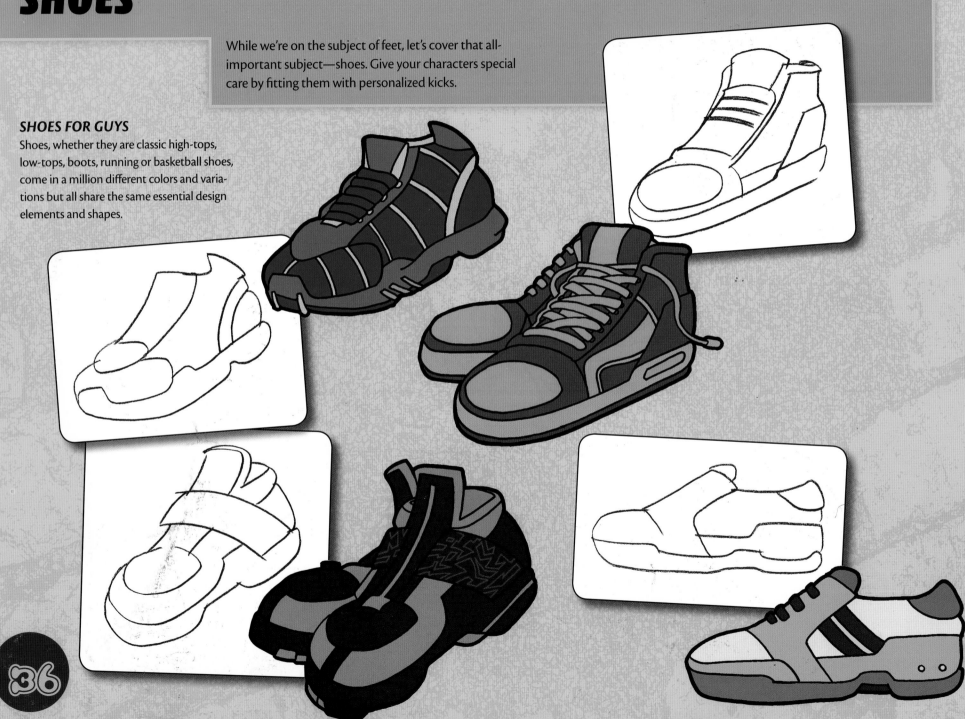

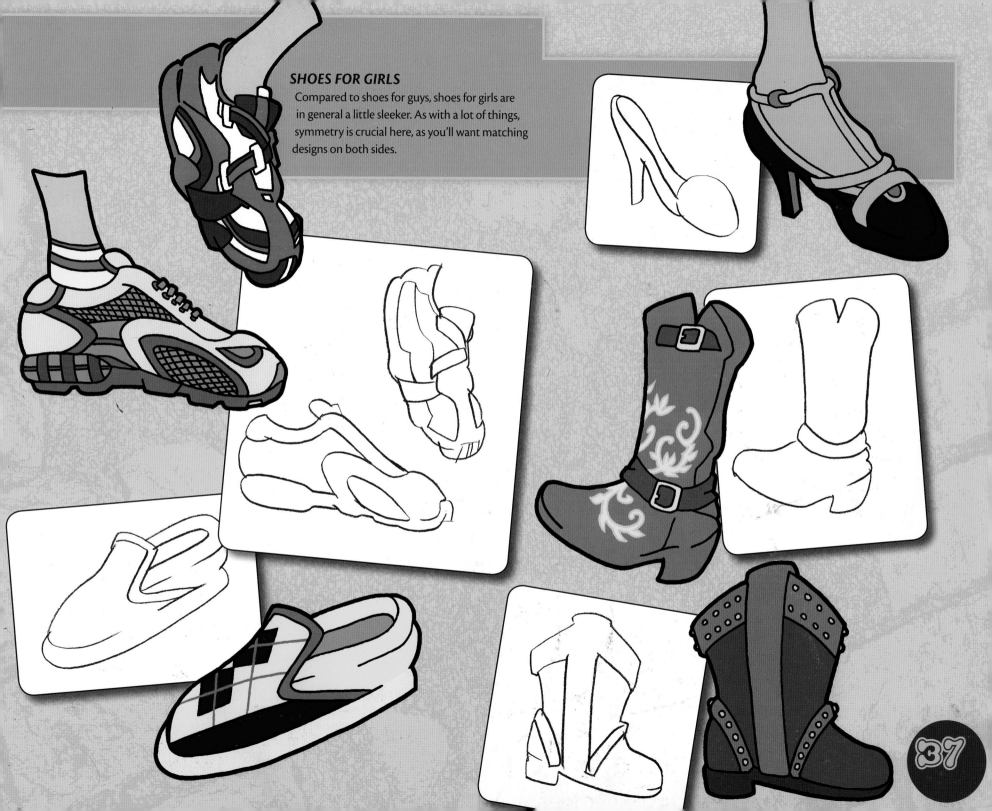

SHOES FOR GIRLS

Compared to shoes for guys, shoes for girls are in general a little sleeker. As with a lot of things, symmetry is crucial here, as you'll want matching designs on both sides.

CLOTHING STYLES FOR GIRLS

Different clothing and accessories reveal personality and soul. There are three main looks to build off. Once you figure out a look or style for your subject, you can just mix and match to see what looks best. When you break down everything into individual pieces, it becomes easy to draw clothes and accessories. Just like everything else you'll draw, they all consist of basic shapes.

LAID-BACK

Graphic sweats and slouchy pants are key items in making your cool, urban laid-back characters look the part. Her colored multistranded necklace and the graffiti print on her zip-front hoodie are key elements as well.

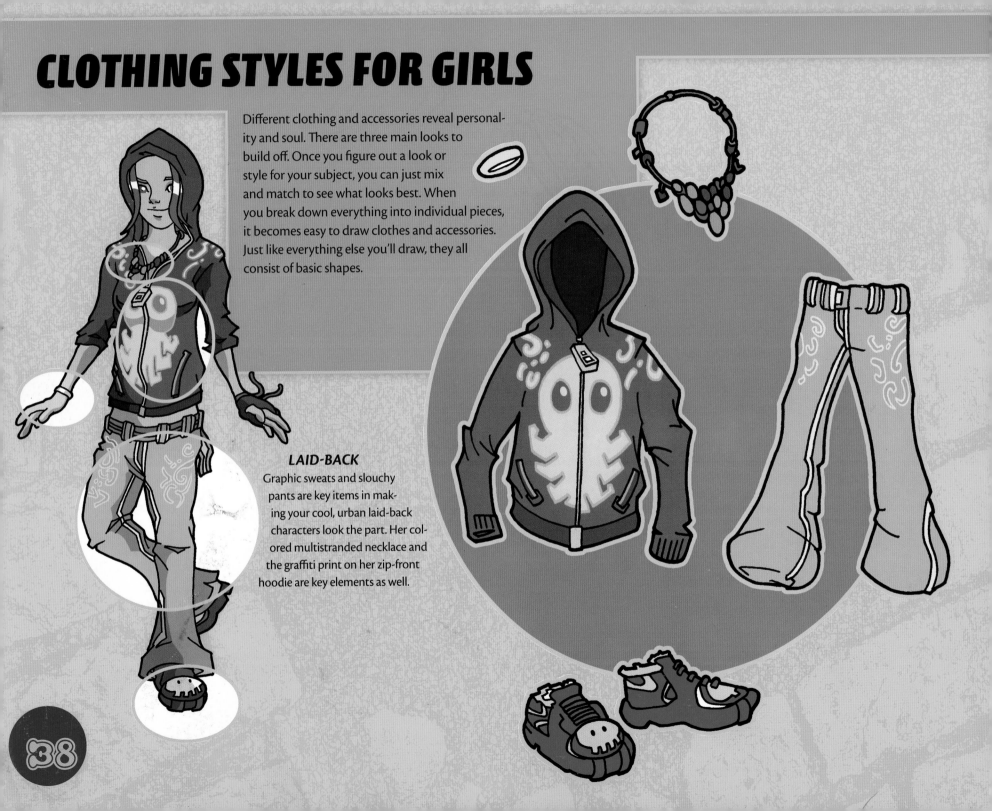

CLASSIC

Key items include comfortable T-shirts and jeans, beaded medallion necklaces, bangles and sandals.

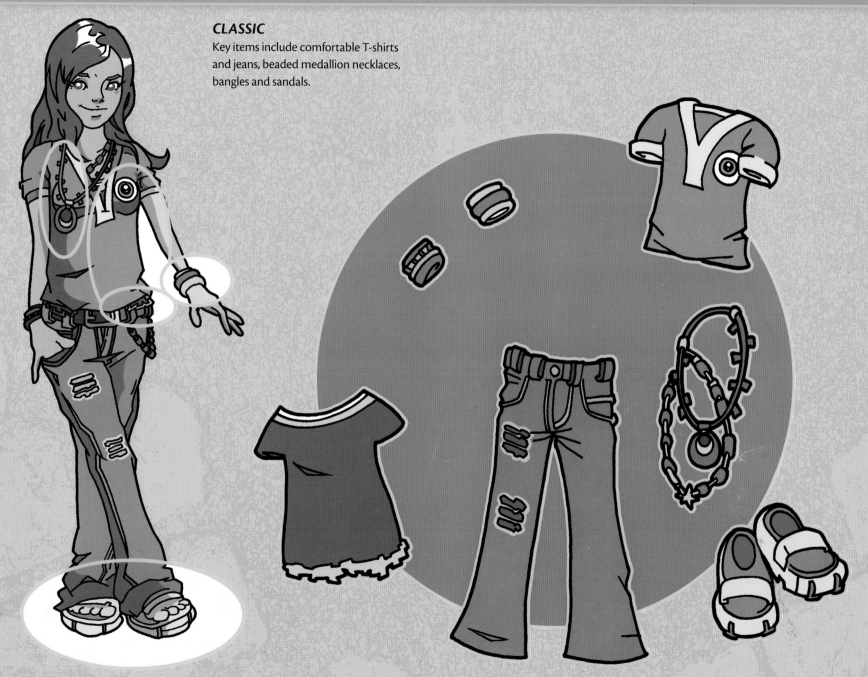

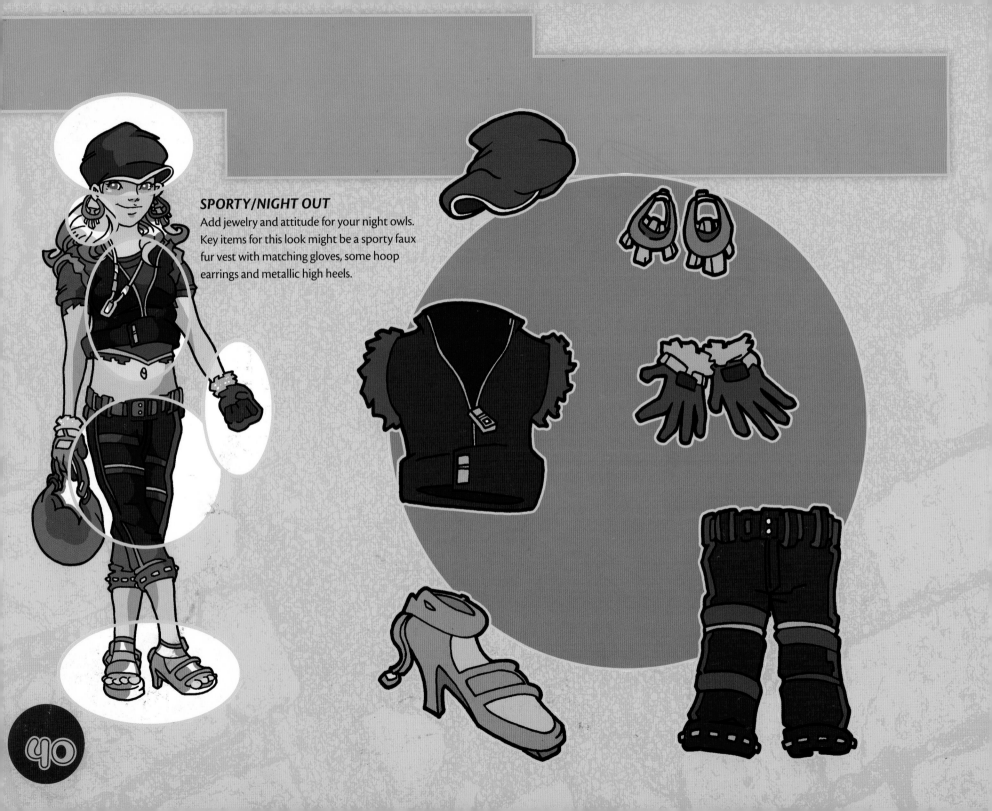

SPORTY/NIGHT OUT

Add jewelry and attitude for your night owls. Key items for this look might be a sporty faux fur vest with matching gloves, some hoop earrings and metallic high heels.

CLOTHING STYLES FOR GUYS

Though, admittedly, there are many more, you can build off three different styles for guys, too: a sporty and athletic look, a skater look and a hip-hop look. And their accessories, clothing and hairstyles are just as individualized as their female counterparts.

ATHLETIC
Headbands, track jackets and pants, basketball shoes—these are essentials for the athlete ready to school all his bros on the blacktop. Draw in more creases and folds with most guys' clothing.

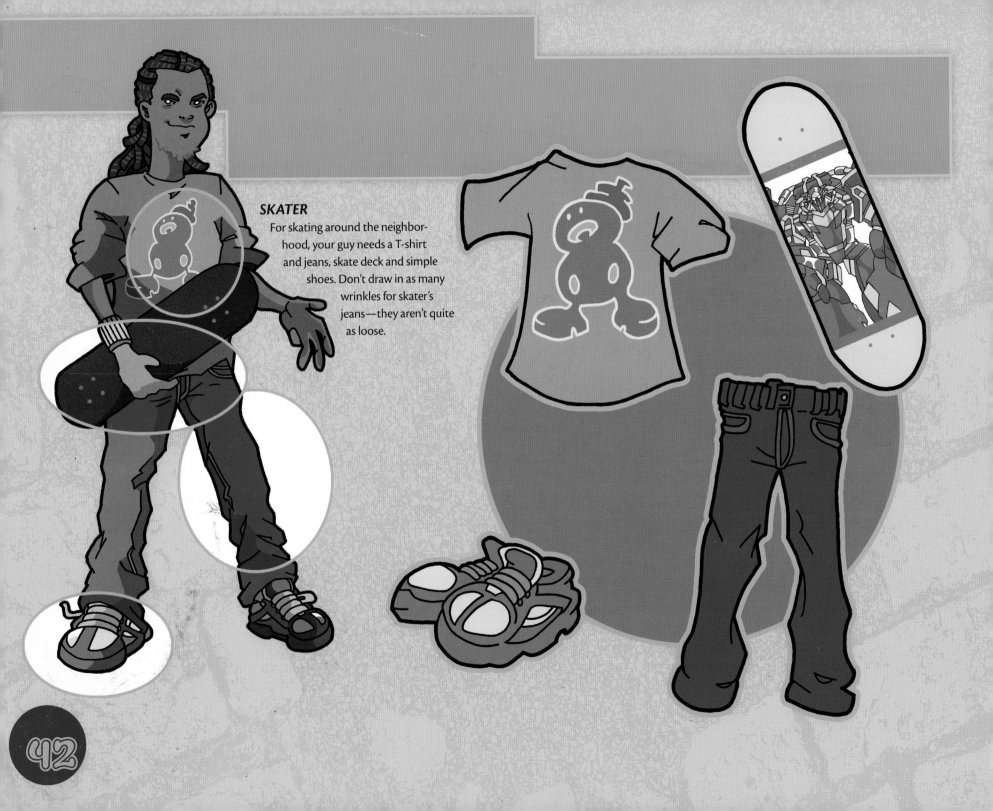

SKATER

For skating around the neighborhood, your guy needs a T-shirt and jeans, skate deck and simple shoes. Don't draw in as many wrinkles for skater's jeans—they aren't quite as loose.

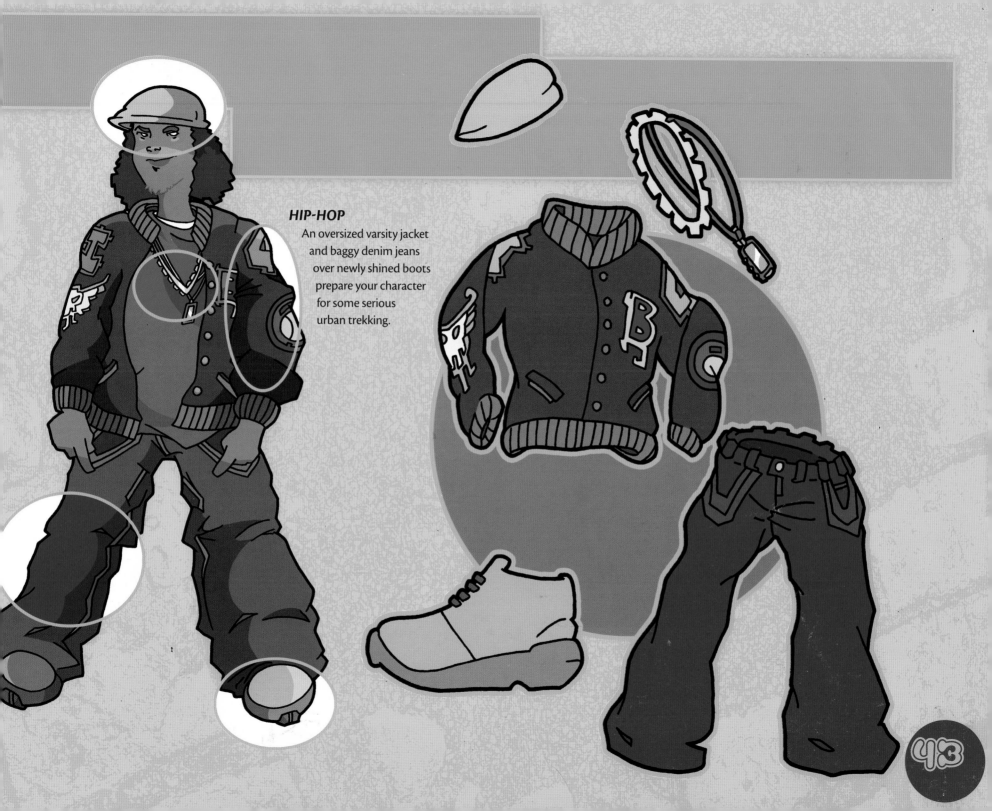

HIP-HOP

An oversized varsity jacket and baggy denim jeans over newly shined boots prepare your character for some serious urban trekking.

JEWELRY AND BLING

By now you've seen that characters with style need accessories. Practice drawing the basic shapes and move from there.

FROM EARRINGS...

TO NECKLACES...

TO BRACELETS, BANGLES, WATCHES AND STUDS...

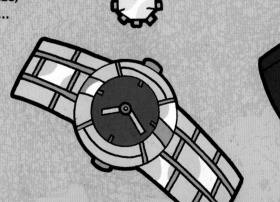

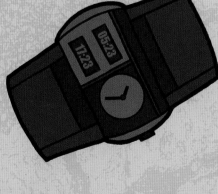

...ALL JEWELRY IS CREATED WITH THE SAME SIMPLE SHAPES AND SHADING.

GLASSES AND HATS

Glasses and hats are almost always very simple shapes.
No matter what shape you make them, keep them symmetrical. The shapes on either side should match.

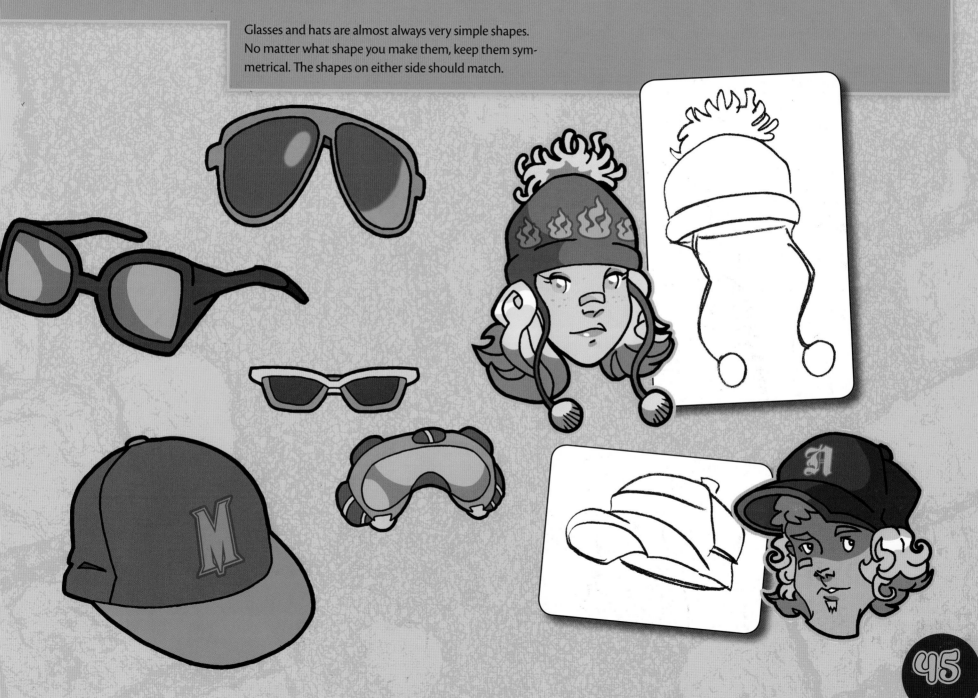

BAGS

We've all got stuff to carry… luckily you can draw them all with the same basic shapes you've been using all along.

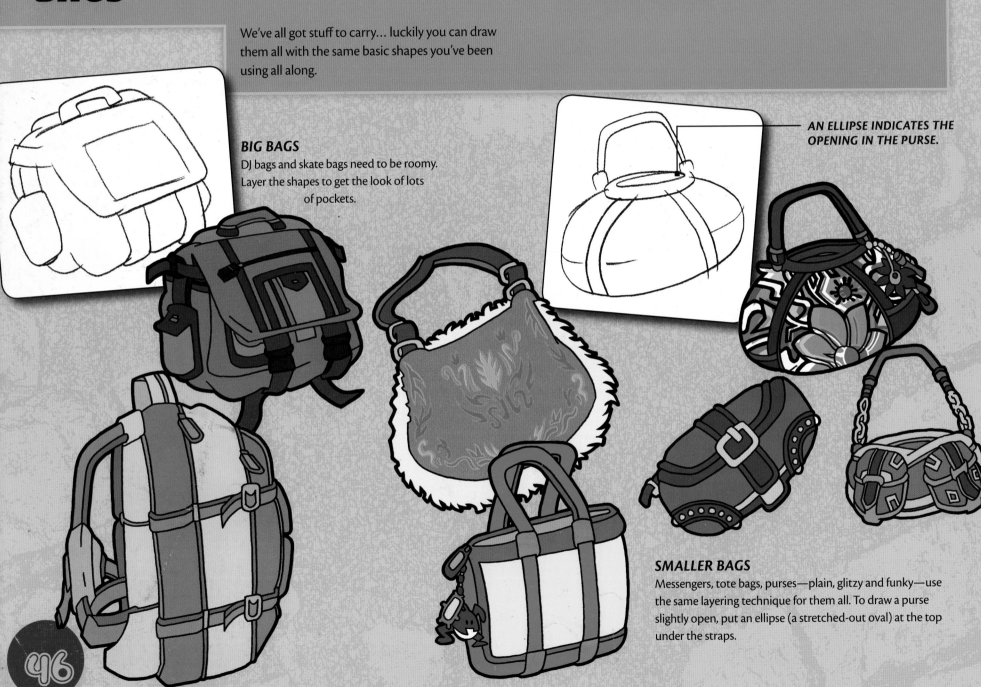

BIG BAGS
DJ bags and skate bags need to be roomy. Layer the shapes to get the look of lots of pockets.

AN ELLIPSE INDICATES THE OPENING IN THE PURSE.

SMALLER BAGS
Messengers, tote bags, purses—plain, glitzy and funky—use the same layering technique for them all. To draw a purse slightly open, put an ellipse (a stretched-out oval) at the top under the straps.

PIERCINGS AND TATTOOS

Body art and piercings will really give your characters personality. They're pretty easy to draw, too.

PIERCINGS

Whether piercings are on the ears, brow, nose, lip or tongue, remember to indicate shadows and highlights. Metal piercings will have a white highlight where the light hits and will cast a shadow on the opposite side.

TATTOOS

Since tattoos are part of the skin they must conform to whatever viewpoint you're drawing your character from. The full design on this guy's neck can be seen inside the circle.

BE CREATIVE!

Go nuts with tattoos and create really elaborate designs.

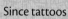

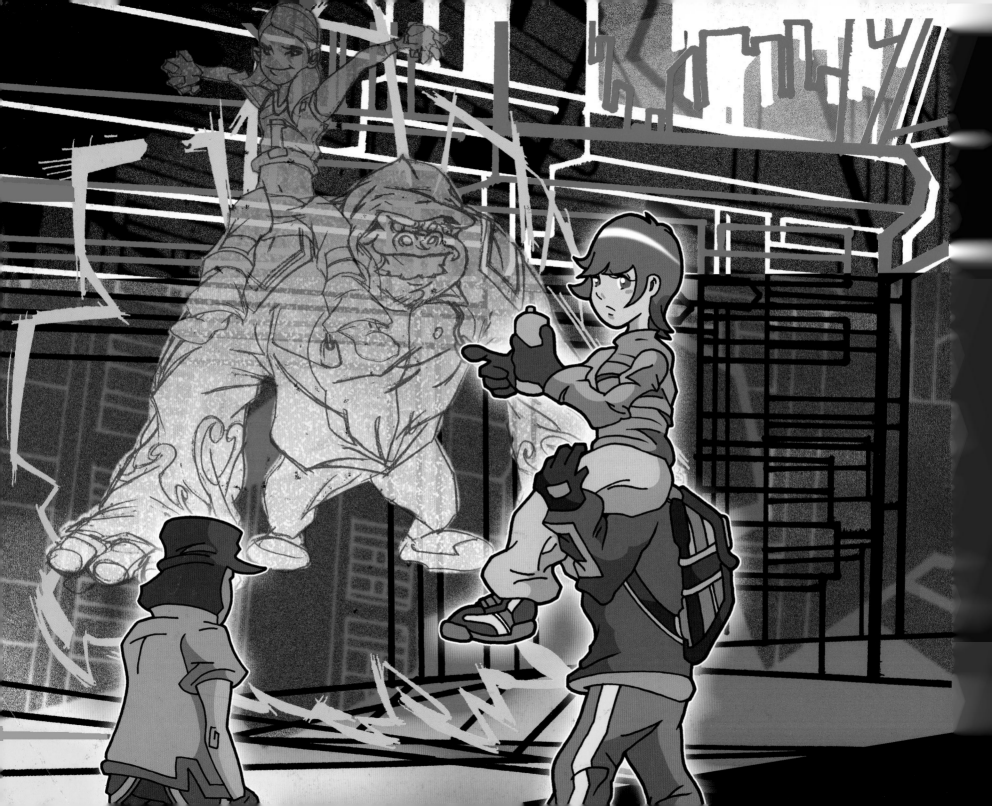

3

PEOPLE— PUTTING IT ALL TOGETHER

GUYS—BASIC CONSTRUCTION

The stick figure, or gesture drawing, is useful for figuring out pose and gesture. As you learned on page 33, the bubble figure will help to realize your character's mass. Always draw the bubble before the character to get a solid view of height, weight and action.

TYPES OF PEOPLE

There are many different "types" of people to draw in this chapter, but this is by no means an exhaustive list. Copy these in part or entirely, then make your own adjustments to express your own style.

BASIC MALE BUBBLE MODEL

Think of the body as puzzle pieces that fit together to make a whole. Consider the body in sections. From the top: head and neck, shoulders and chest, arms and legs. Each arm has three parts: shoulder to elbow, elbow to wrist, and hand. Break legs into four parts: the thigh, the brightly colored knee connecting to the ankle and finally the foot. The exact look of the model will vary with your characters. Just remember that they all share the same parts. Male characters are usually taller than females, shoulders broader, and arms and legs thicker.

Draw the bubble figure around your gesture, drawing in separate shapes.

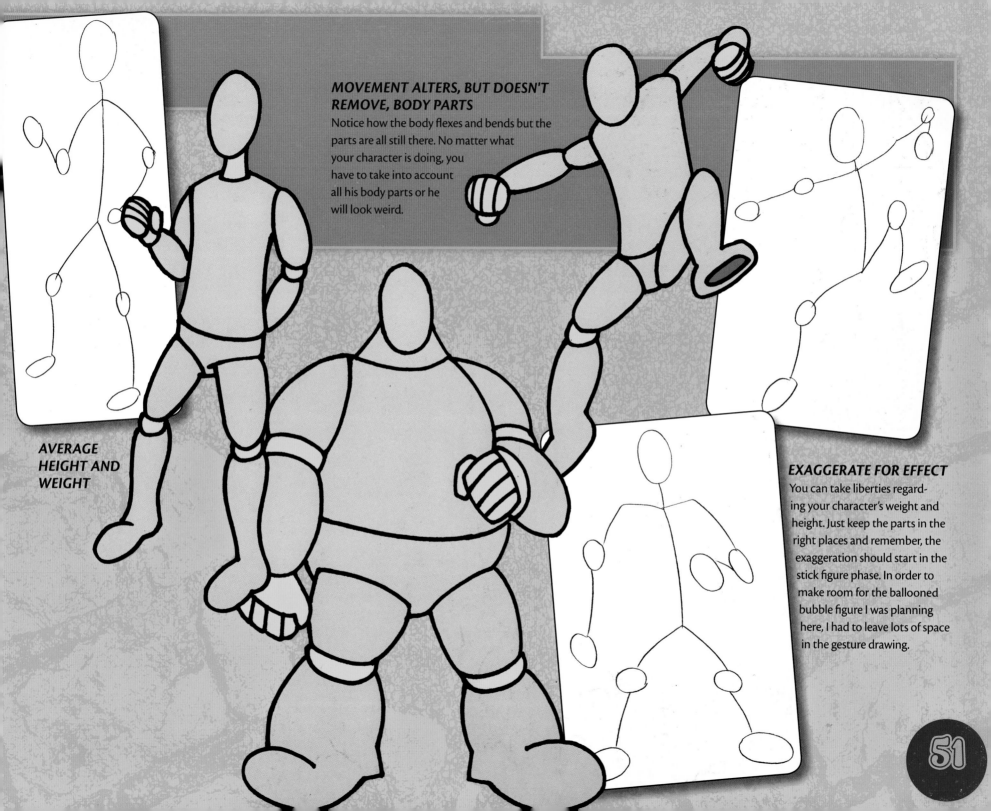

MOVEMENT ALTERS, BUT DOESN'T REMOVE, BODY PARTS
Notice how the body flexes and bends but the parts are all still there. No matter what your character is doing, you have to take into account all his body parts or he will look weird.

AVERAGE HEIGHT AND WEIGHT

EXAGGERATE FOR EFFECT
You can take liberties regarding your character's weight and height. Just keep the parts in the right places and remember, the exaggeration should start in the stick figure phase. In order to make room for the ballooned bubble figure I was planning here, I had to leave lots of space in the gesture drawing.

51

GIRLS—BASIC CONSTRUCTION

Females should look smaller and more feminine than males. If you're drawing taller and heavier females, they should look athletic instead of bulky. In the final picture, girls' bodies also should look softer and rounder as opposed to having noticeable muscular definition.

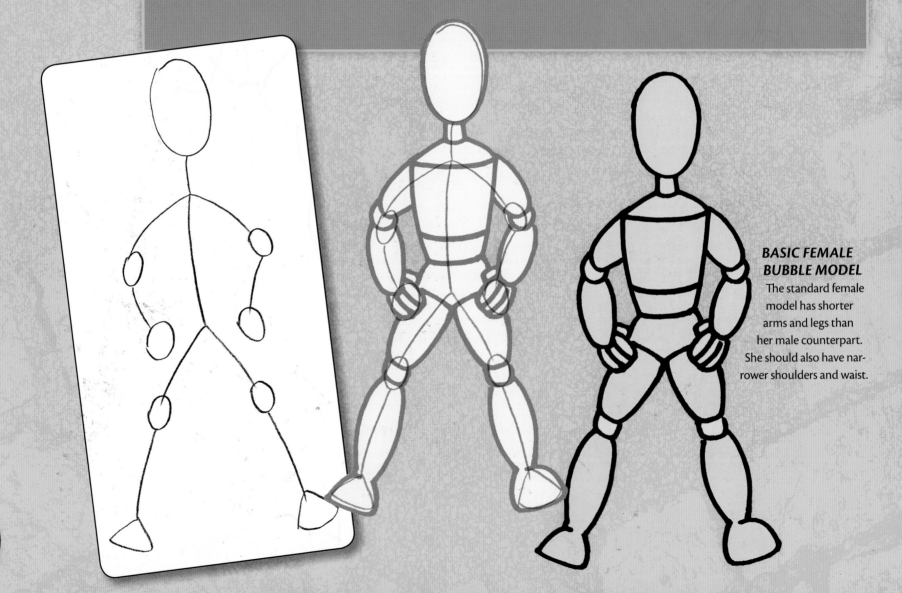

BASIC FEMALE BUBBLE MODEL
The standard female model has shorter arms and legs than her male counterpart. She should also have narrower shoulders and waist.

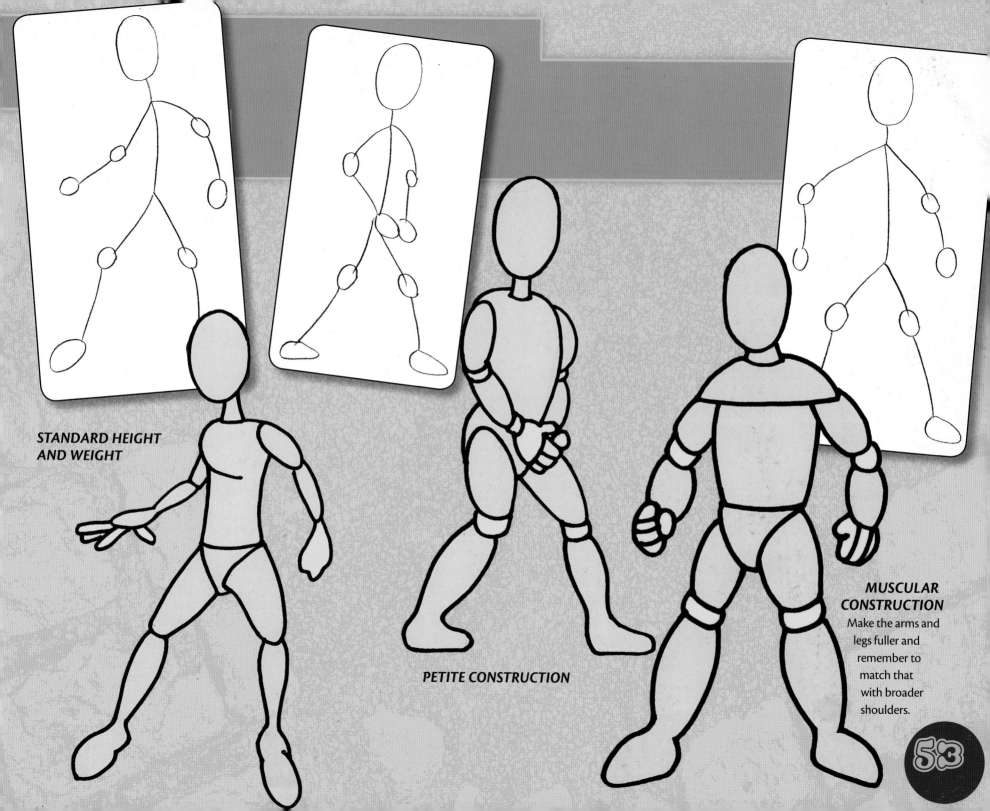

STANDARD HEIGHT AND WEIGHT

PETITE CONSTRUCTION

MUSCULAR CONSTRUCTION
Make the arms and legs fuller and remember to match that with broader shoulders.

53

SINGER

VERONICA :: *She started out doing local talent shows, but now she draws huge crowds. Veronica's a centered family girl with a truckload of determination.*

CONSIDER YOUR CHARACTERS' CHARACTERISTICS

The personalities of the people you draw and paint should affect how you create them. Every time you create a character, think of what that person is like. Give your characters names even. Characters' traits should inform your drawings.

 Let one hand disappear behind her head. Veronica will be holding a microphone, too, so leave one hand empty.

 Draw the shapes for the bubble model using the stick figure as a guide. Veronica is fairly young so her proportions should be rather short and slight.

54

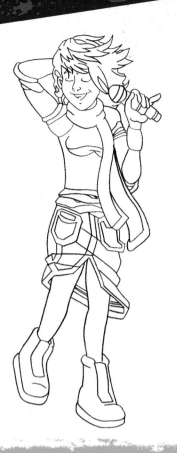

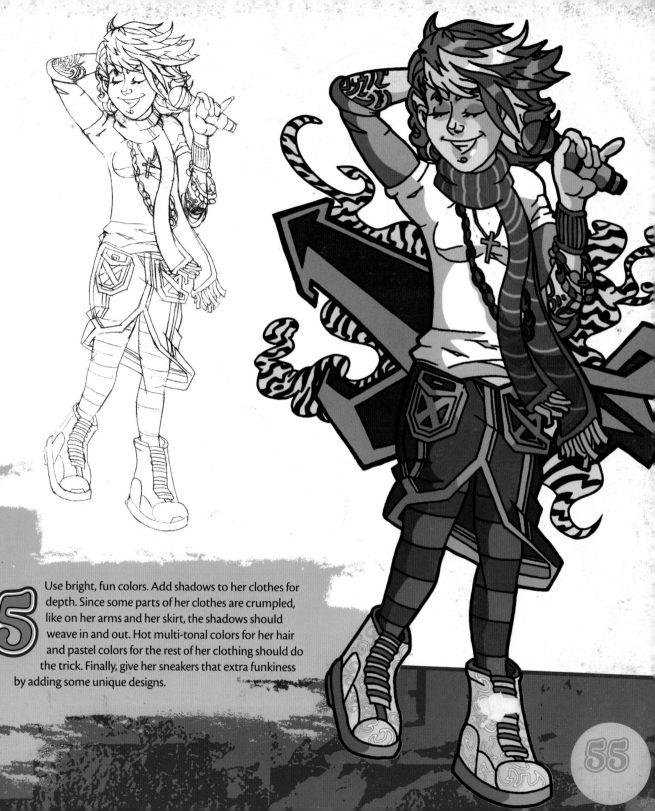

3 Give her a smile. Turn to page 32 to review drawing expressions. Closed eyes are nearly as simple as little half-moon lines. Her clothes should only be wrinkled or rumpled where her arms are bent. Draw as separate shapes her scarf, her T-shirt where it will wrinkle, and draw in the basic shape of the shadow on her chest.

Refine the drawing. Put in details such as pockets on her skirt and shoelaces. Add some tattoos creeping out through the sleeves of her rolled-up shirt. Cut them off **4** so it looks like they're extending across her upper arm. Draw divisions on her hair like little triangles. Indicate the folds and creases of her clothes with broken shapes and lines so it will be easier when you color in the shadows. Remember, the tops of the folds will catch the highlight and the valleys of the folds will be cast in shadow.

5 Use bright, fun colors. Add shadows to her clothes for depth. Since some parts of her clothes are crumpled, like on her arms and her skirt, the shadows should weave in and out. Hot multi-tonal colors for her hair and pastel colors for the rest of her clothing should do the trick. Finally, give her sneakers that extra funkiness by adding some unique designs.

55

GUITARIST

JACKSON :: *Every time he performs you just know that everyone's going to have a really fun and magical experience they'll never forget. Jackson's more concerned with his craft and music, but if fame follows, he won't complain.*

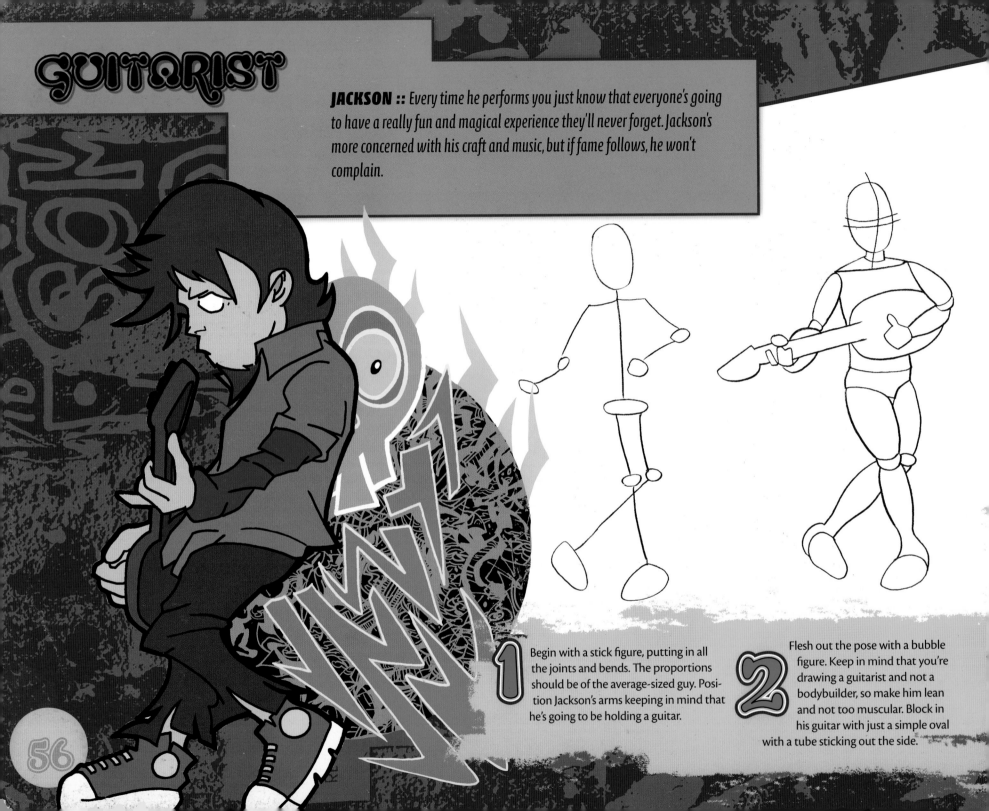

1 Begin with a stick figure, putting in all the joints and bends. The proportions should be of the average-sized guy. Position Jackson's arms keeping in mind that he's going to be holding a guitar.

2 Flesh out the pose with a bubble figure. Keep in mind that you're drawing a guitarist and not a bodybuilder, so make him lean and not too muscular. Block in his guitar with just a simple oval with a tube sticking out the side.

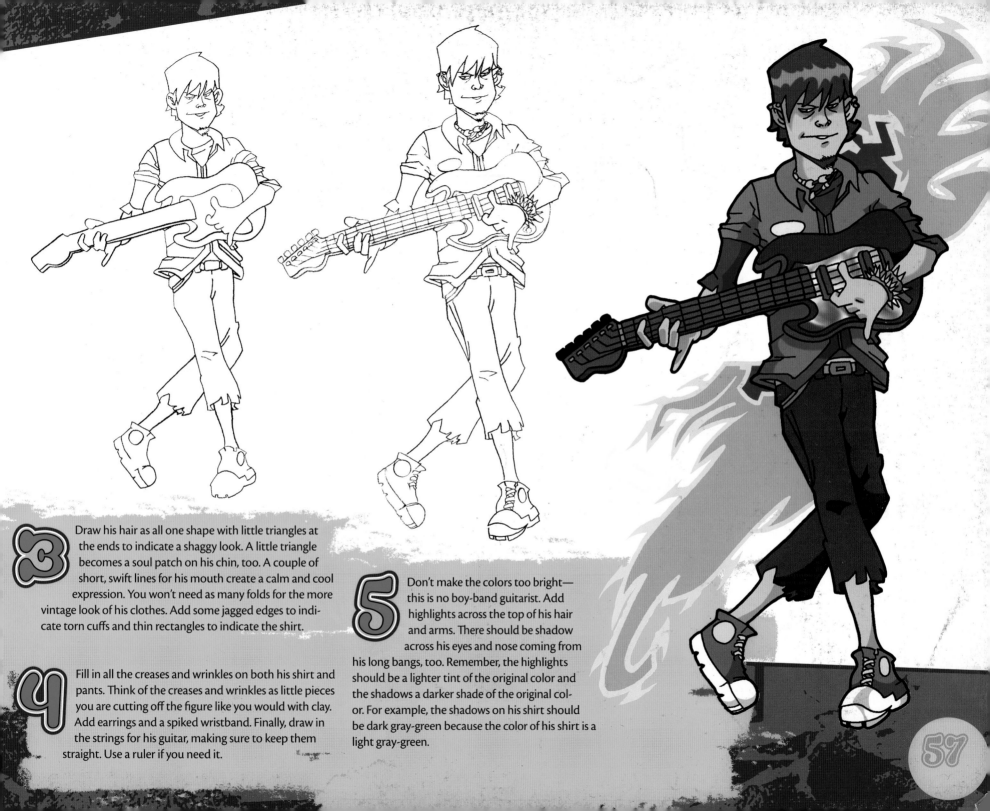

3 Draw his hair as all one shape with little triangles at the ends to indicate a shaggy look. A little triangle becomes a soul patch on his chin, too. A couple of short, swift lines for his mouth create a calm and cool expression. You won't need as many folds for the more vintage look of his clothes. Add some jagged edges to indicate torn cuffs and thin rectangles to indicate the shirt.

4 Fill in all the creases and wrinkles on both his shirt and pants. Think of the creases and wrinkles as little pieces you are cutting off the figure like you would with clay. Add earrings and a spiked wristband. Finally, draw in the strings for his guitar, making sure to keep them straight. Use a ruler if you need it.

5 Don't make the colors too bright—this is no boy-band guitarist. Add highlights across the top of his hair and arms. There should be shadow across his eyes and nose coming from his long bangs, too. Remember, the highlights should be a lighter tint of the original color and the shadows a darker shade of the original color. For example, the shadows on his shirt should be dark gray-green because the color of his shirt is a light gray-green.

HIP-HOP ARTIST

JULIUS :: Julius is a modern-day bard, a great rapper who captivates his audiences with stories, weaving thoughts and feelings into lyrical rhymes. He understands the power of the spoken word.

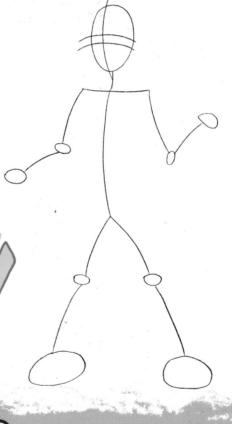

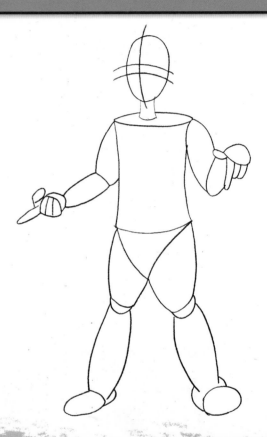

 Begin by drawing a stick figure. Draw his arms and legs fairly far apart. Go ahead and mark the guidelines for his face now, too.

 Draw the bubble model large enough to leave room for oversized clothes. It's important for a rapper to express with his hands, so sketch those in as well. Square off his shoulders and draw strong hand gestures to portray confidence.

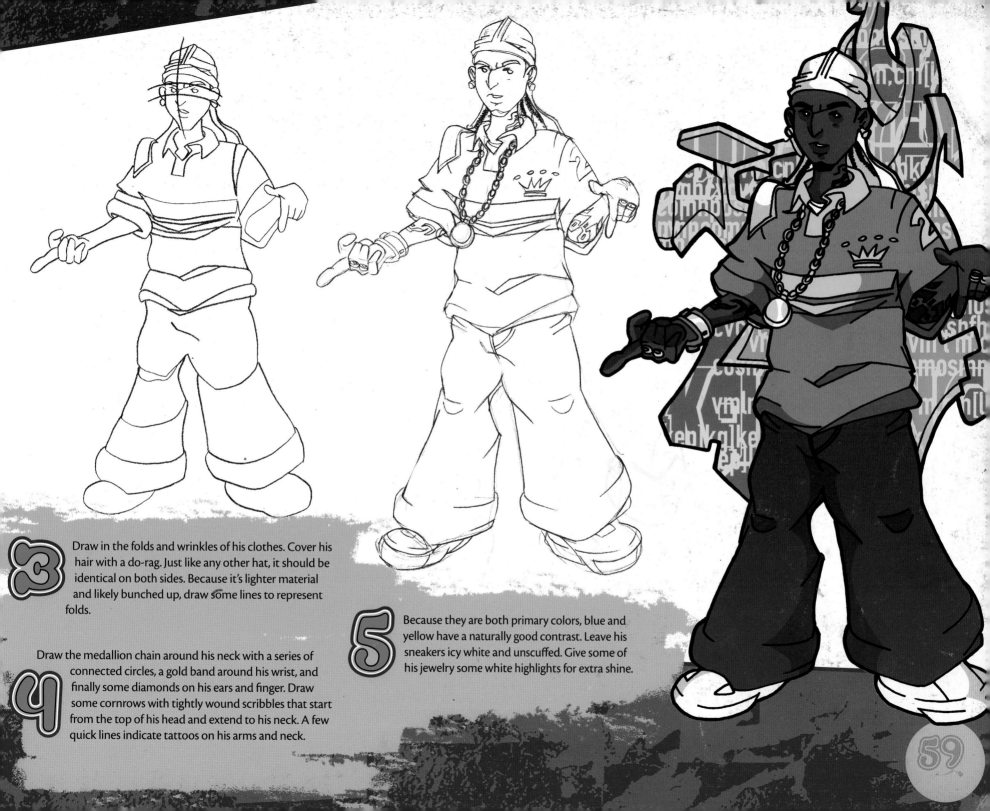

3 Draw in the folds and wrinkles of his clothes. Cover his hair with a do-rag. Just like any other hat, it should be identical on both sides. Because it's lighter material and likely bunched up, draw some lines to represent folds.

4 Draw the medallion chain around his neck with a series of connected circles, a gold band around his wrist, and finally some diamonds on his ears and finger. Draw some cornrows with tightly wound scribbles that start from the top of his head and extend to his neck. A few quick lines indicate tattoos on his arms and neck.

5 Because they are both primary colors, blue and yellow have a naturally good contrast. Leave his sneakers icy white and unscuffed. Give some of his jewelry some white highlights for extra shine.

GRAFFITI ARTIST | MALE

HP3Z :: HP3Z spends the daytime planning and scoping out different locales, but it's at night that he gets the job done. The satisfaction that he gets when people wonder, "Who did that?" or better yet, "How did he do that?" means a lot to him. He does it for the thrill and for the art itself and takes great care and pride in his craft. He wants every one of his pieces to be a masterpiece.

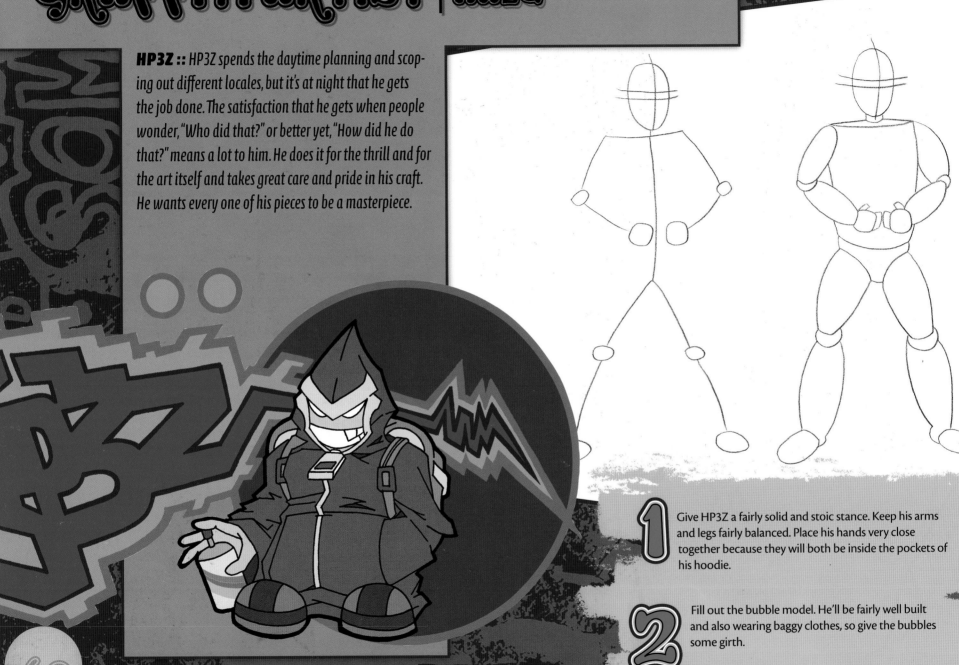

1 Give HP3Z a fairly solid and stoic stance. Keep his arms and legs fairly balanced. Place his hands very close together because they will both be inside the pockets of his hoodie.

2 Fill out the bubble model. He'll be fairly well built and also wearing baggy clothes, so give the bubbles some girth.

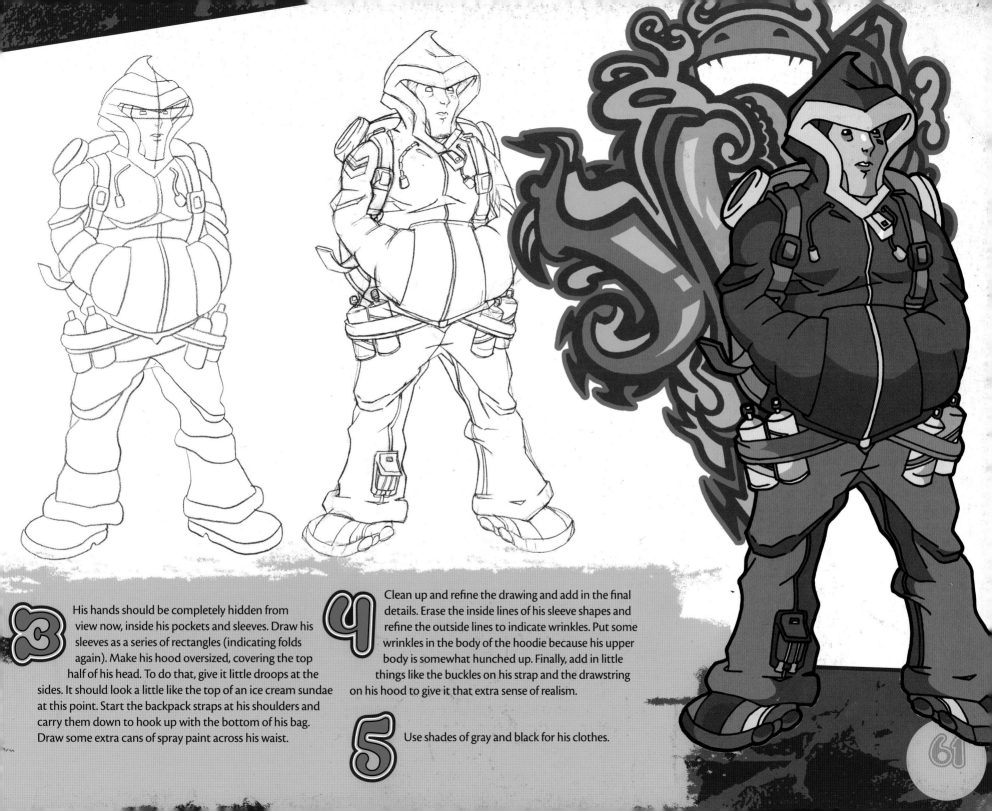

3 His hands should be completely hidden from view now, inside his pockets and sleeves. Draw his sleeves as a series of rectangles (indicating folds again). Make his hood oversized, covering the top half of his head. To do that, give it little droops at the sides. It should look a little like the top of an ice cream sundae at this point. Start the backpack straps at his shoulders and carry them down to hook up with the bottom of his bag. Draw some extra cans of spray paint across his waist.

4 Clean up and refine the drawing and add in the final details. Erase the inside lines of his sleeve shapes and refine the outside lines to indicate wrinkles. Put some wrinkles in the body of the hoodie because his upper body is somewhat hunched up. Finally, add in little things like the buckles on his strap and the drawstring on his hood to give it that extra sense of realism.

5 Use shades of gray and black for his clothes.

TIFF :: Tiff is the girl who is always doodling and drawing in her notebook, in between all the notes of course, during class. I guess you could call her one hardcore notebook tagger. She also has a special book where she keeps all her tags. She's practiced on her room wall and backyard shed. She never considered herself an artist, but tagging has tapped a creative side in Tiff that she never realized she had.

1 Draw Tiff in a crouching pose as she is just about to cap off her mark. One knee should be jutting out while her other rests on the ground. Put one arm pointing right at you and her other arm pointing down as she'll be holding her paint canister there.

2 Tiff is a teenage girl so her arms and legs shouldn't be overly long. Since her arms are bent, they will be even shorter. Use the elbow joint between the two arm bubbles to indicate the position.

REC.

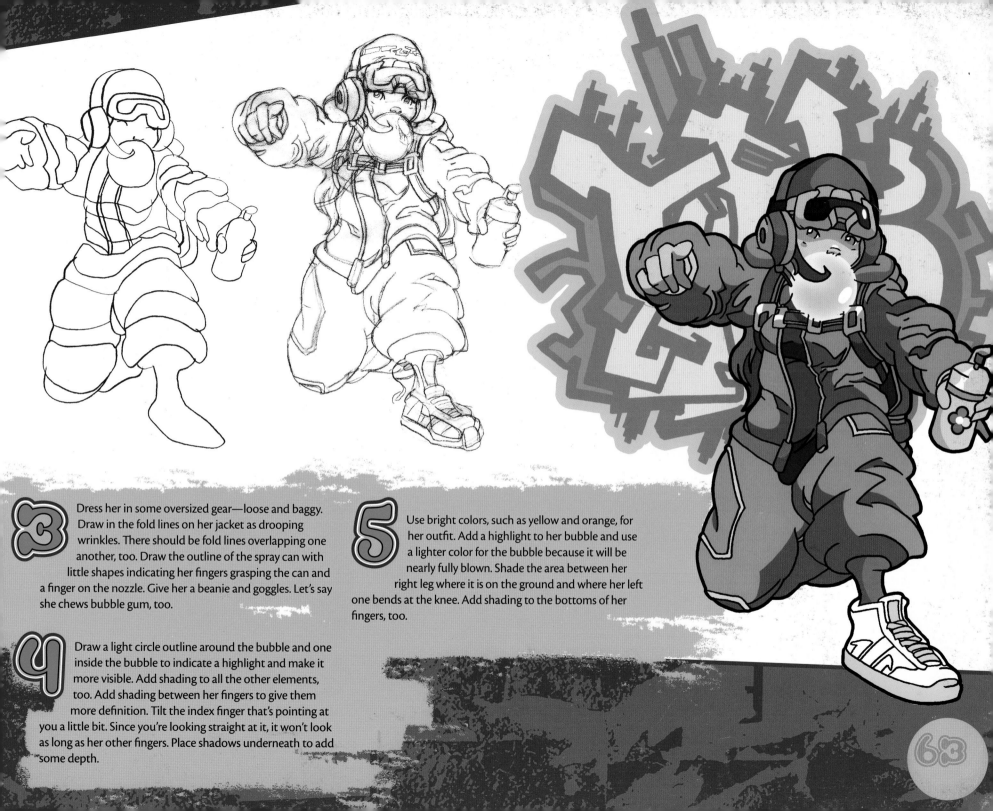

3 Dress her in some oversized gear—loose and baggy. Draw in the fold lines on her jacket as drooping wrinkles. There should be fold lines overlapping one another, too. Draw the outline of the spray can with little shapes indicating her fingers grasping the can and a finger on the nozzle. Give her a beanie and goggles. Let's say she chews bubble gum, too.

4 Draw a light circle outline around the bubble and one inside the bubble to indicate a highlight and make it more visible. Add shading to all the other elements, too. Add shading between her fingers to give them more definition. Tilt the index finger that's pointing at you a little bit. Since you're looking straight at it, it won't look as long as her other fingers. Place shadows underneath to add some depth.

5 Use bright colors, such as yellow and orange, for her outfit. Add a highlight to her bubble and use a lighter color for the bubble because it will be nearly fully blown. Shade the area between her right leg where it is on the ground and where her left one bends at the knee. Add shading to the bottoms of her fingers, too.

DJ | MALE

VAN :: Van hears beats in his head night and day, although sometimes that's from running into walls and lampposts due to closed eyes and headphones. The day that Van got a music mixing program for his computer will stand as the day that changed his life.

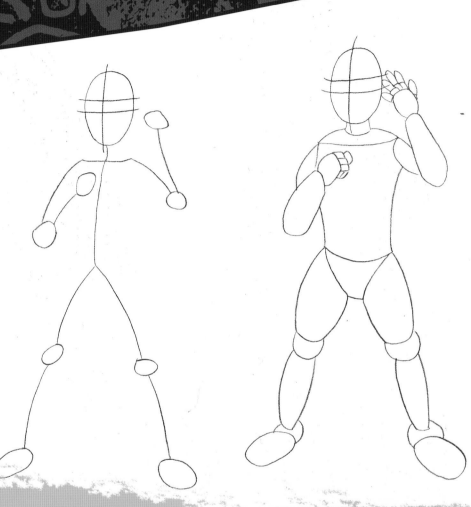

1 Draw a basic stick figure, nothing fancy. Put one hand close to his chest where he'll be holding his bag strap and the other close to his head where he'll be holding headphones.

2 Fill out the bubble figure. His arms are bent, so they will twist at the elbow joints, rendering them nearly invisible. Note that the top and bottom arm shapes overlap one another. Draw his closed fist with a square and a series of little rectangles.

REC.

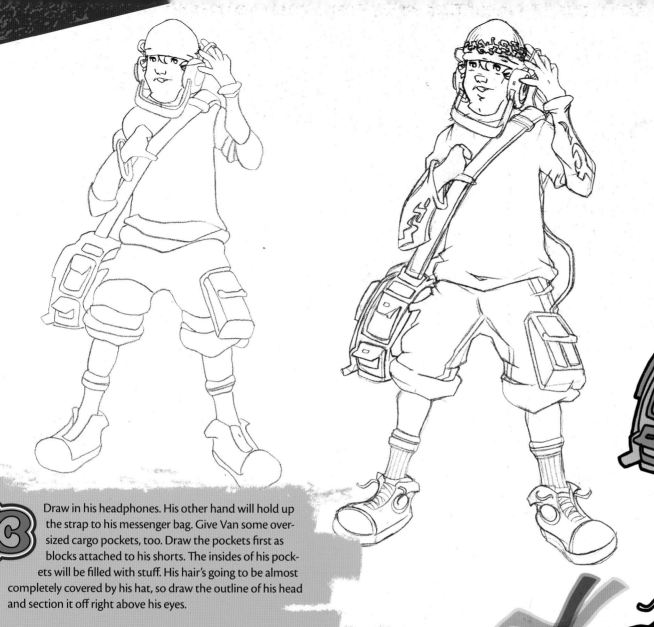

3 Draw in his headphones. His other hand will hold up the strap to his messenger bag. Give Van some oversized cargo pockets, too. Draw the pockets first as blocks attached to his shorts. The insides of his pockets will be filled with stuff. His hair's going to be almost completely covered by his hat, so draw the outline of his head and section it off right above his eyes.

4 Refine the details from previous steps. Draw a cord from his pocket to his headphones (his player's in his pocket). Draw his tube socks high up his calves. Draw a little repeating design on his hat. Make creases in his shorts where his legs are bending and where the rolls occur.

5 The light source is on the right, so add shading to the other side of his face. Remember to shade the bottoms of the folds and his legs where the shadows of his pants fall.

DJ | FEMALE

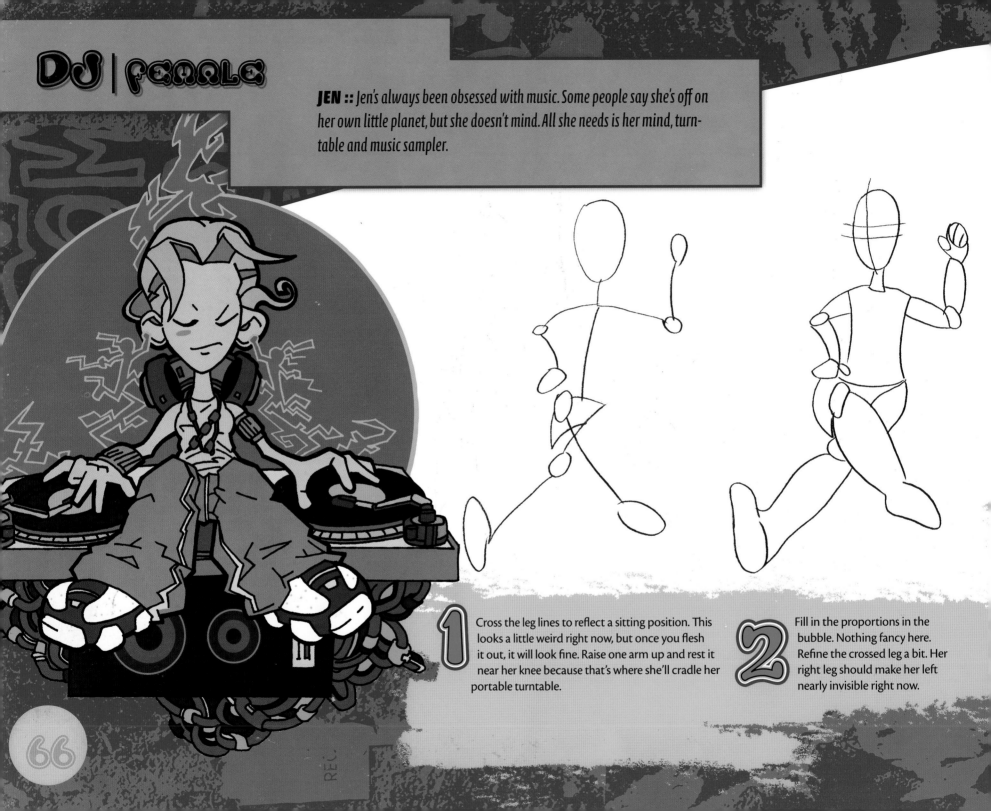

1 Cross the leg lines to reflect a sitting position. This looks a little weird right now, but once you flesh it out, it will look fine. Raise one arm up and rest it near her knee because that's where she'll cradle her portable turntable.

2 Fill in the proportions in the bubble. Nothing fancy here. Refine the crossed leg a bit. Her right leg should make her left nearly invisible right now.

66

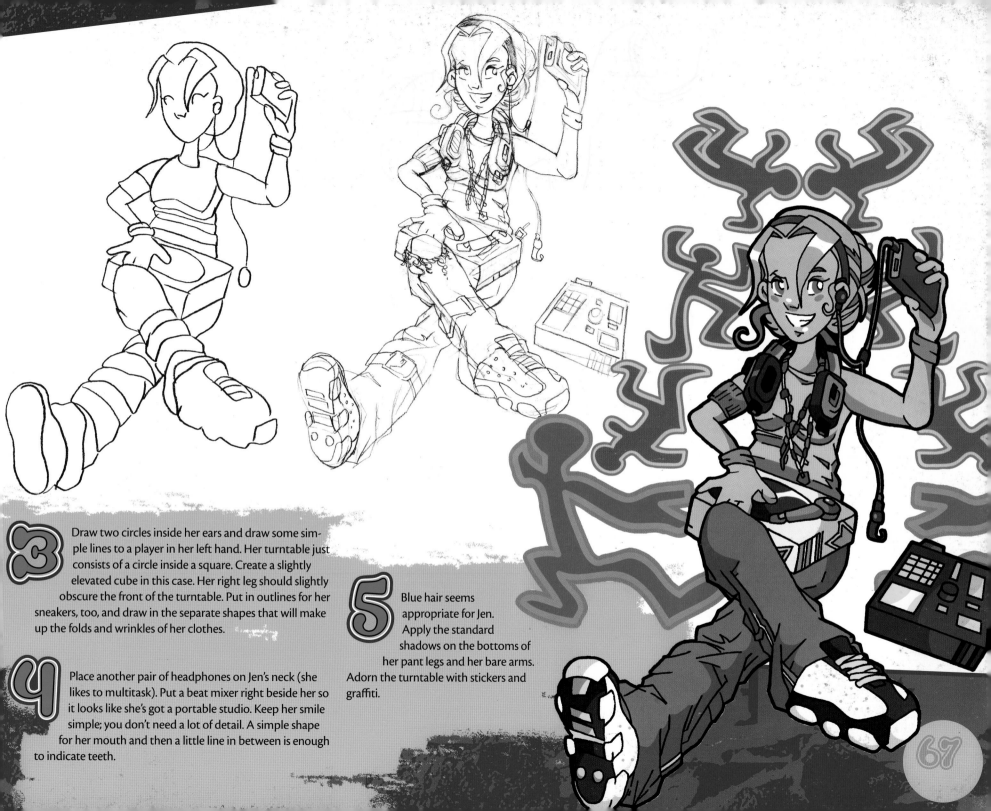

3 Draw two circles inside her ears and draw some simple lines to a player in her left hand. Her turntable just consists of a circle inside a square. Create a slightly elevated cube in this case. Her right leg should slightly obscure the front of the turntable. Put in outlines for her sneakers, too, and draw in the separate shapes that will make up the folds and wrinkles of her clothes.

4 Place another pair of headphones on Jen's neck (she likes to multitask). Put a beat mixer right beside her so it looks like she's got a portable studio. Keep her smile simple; you don't need a lot of detail. A simple shape for her mouth and then a little line in between is enough to indicate teeth.

5 Blue hair seems appropriate for Jen. Apply the standard shadows on the bottoms of her pant legs and her bare arms. Adorn the turntable with stickers and graffiti.

SKATER | MALE

TJ :: TJ's been skating since he was eight and his board was solely responsible for getting him in and out of trouble. He loves performing for crowds, hoping he can inspire one kid to follow his lead and thus awaken a passion for the sport he loves.

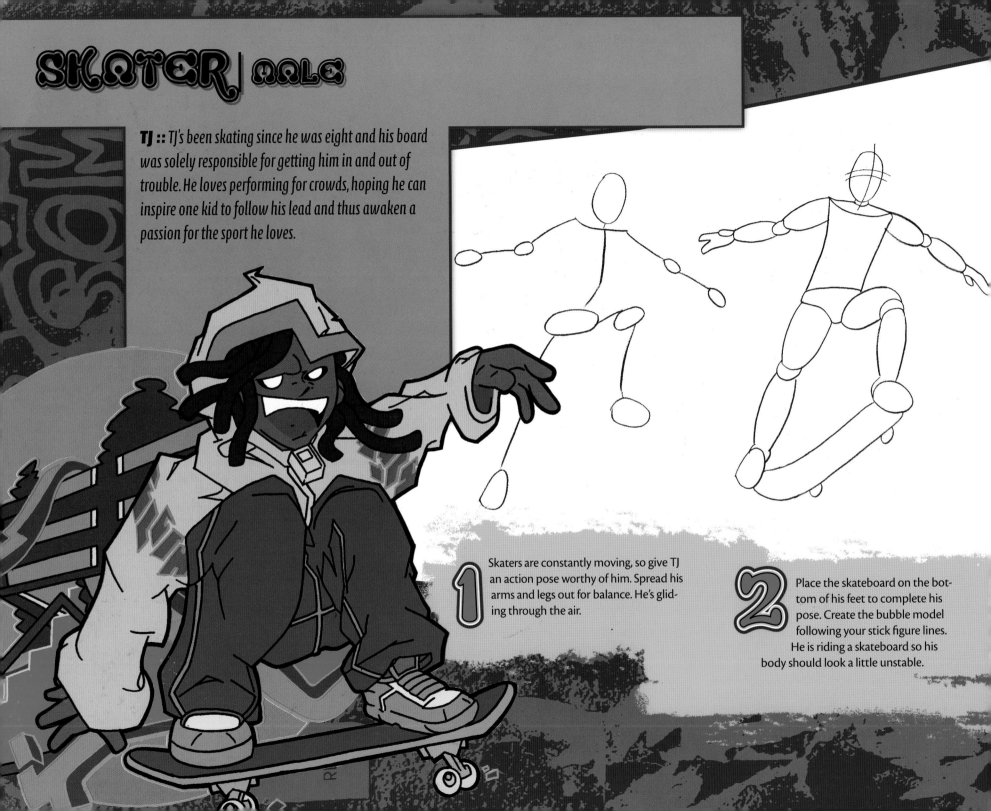

1 Skaters are constantly moving, so give TJ an action pose worthy of him. Spread his arms and legs out for balance. He's gliding through the air.

2 Place the skateboard on the bottom of his feet to complete his pose. Create the bubble model following your stick figure lines. He is riding a skateboard so his body should look a little unstable.

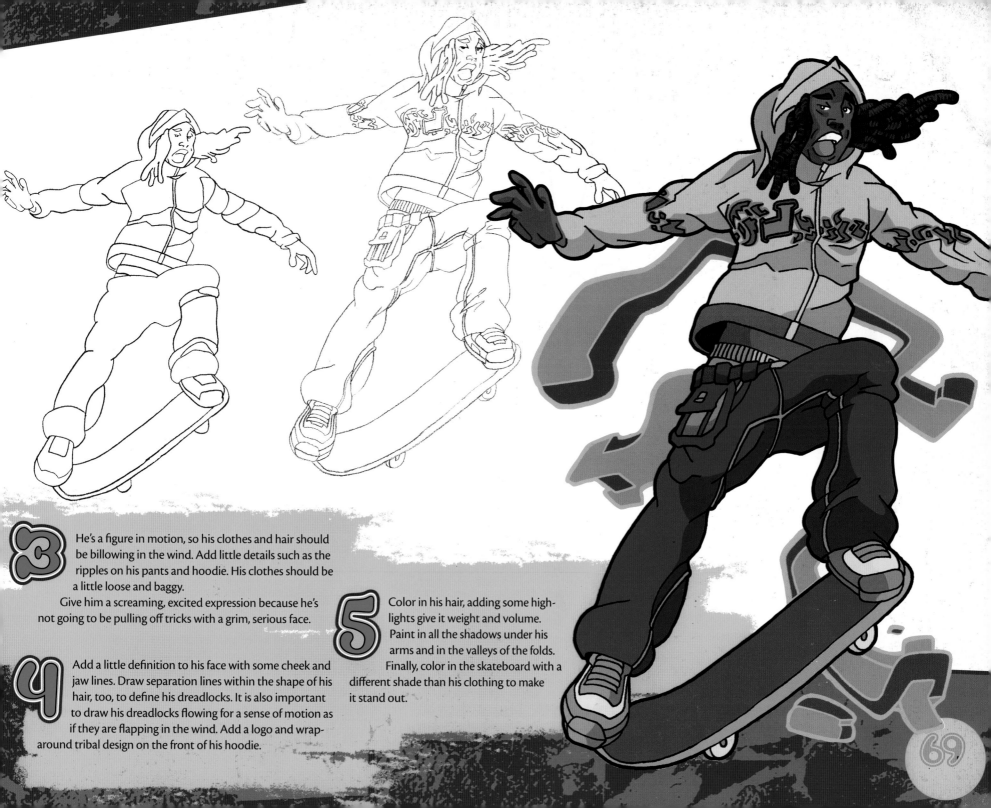

3 He's a figure in motion, so his clothes and hair should be billowing in the wind. Add little details such as the ripples on his pants and hoodie. His clothes should be a little loose and baggy.

Give him a screaming, excited expression because he's not going to be pulling off tricks with a grim, serious face.

4 Add a little definition to his face with some cheek and jaw lines. Draw separation lines within the shape of his hair, too, to define his dreadlocks. It is also important to draw his dreadlocks flowing for a sense of motion as if they are flapping in the wind. Add a logo and wrap-around tribal design on the front of his hoodie.

5 Color in his hair, adding some highlights give it weight and volume. Paint in all the shadows under his arms and in the valleys of the folds. Finally, color in the skateboard with a different shade than his clothing to make it stand out.

69

SKATER FEMALE

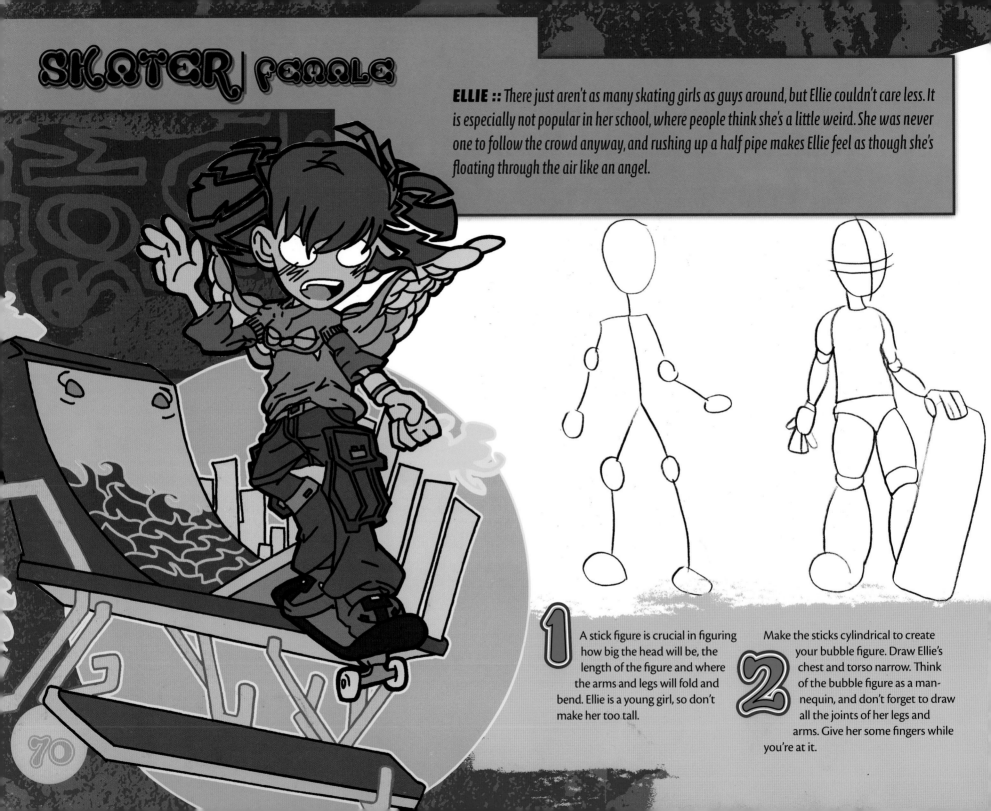

ELLIE :: There just aren't as many skating girls as guys around, but Ellie couldn't care less. It is especially not popular in her school, where people think she's a little weird. She was never one to follow the crowd anyway, and rushing up a half pipe makes Ellie feel as though she's floating through the air like an angel.

1 A stick figure is crucial in figuring how big the head will be, the length of the figure and where the arms and legs will fold and bend. Ellie is a young girl, so don't make her too tall.

2 Make the sticks cylindrical to create your bubble figure. Draw Ellie's chest and torso narrow. Think of the bubble figure as a mannequin, and don't forget to draw all the joints of her legs and arms. Give her some fingers while you're at it.

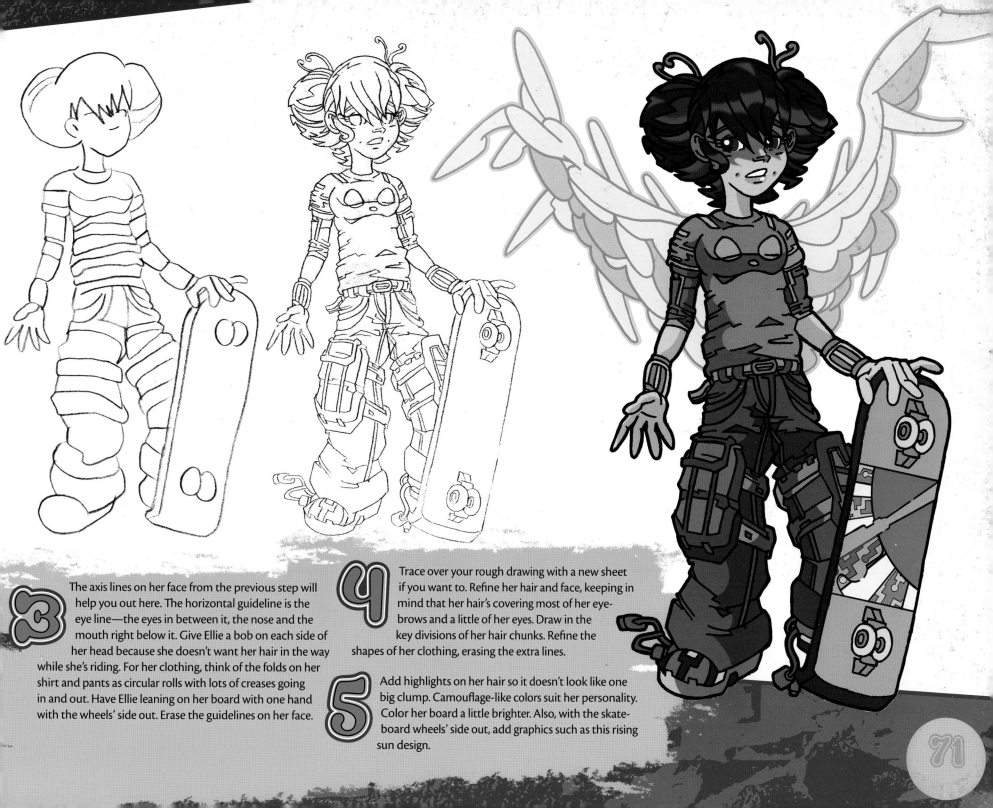

3 The axis lines on her face from the previous step will help you out here. The horizontal guideline is the eye line—the eyes in between it, the nose and the mouth right below it. Give Ellie a bob on each side of her head because she doesn't want her hair in the way while she's riding. For her clothing, think of the folds on her shirt and pants as circular rolls with lots of creases going in and out. Have Ellie leaning on her board with one hand with the wheels' side out. Erase the guidelines on her face.

4 Trace over your rough drawing with a new sheet if you want to. Refine her hair and face, keeping in mind that her hair's covering most of her eyebrows and a little of her eyes. Draw in the key divisions of her hair chunks. Refine the shapes of her clothing, erasing the extra lines.

5 Add highlights on her hair so it doesn't look like one big clump. Camouflage-like colors suit her personality. Color her board a little brighter. Also, with the skateboard wheels' side out, add graphics such as this rising sun design.

BASKETBALL PLAYER

KHALIL :: Only a freshman guard on his high school varsity basketball team, Khalil's already become the team's leader in points, rebounds and assists. He thinks he might be good enough to skip high school altogether, but that would prevent him from earning something far greater in his mind, a diploma. He always promised his parents that they would get a chance to attend his graduation. Algebra 1 and World History 3 might be a little harder than splitting the double team, but Khalil knows the rewards will be far greater than hitting a game-winning shot.

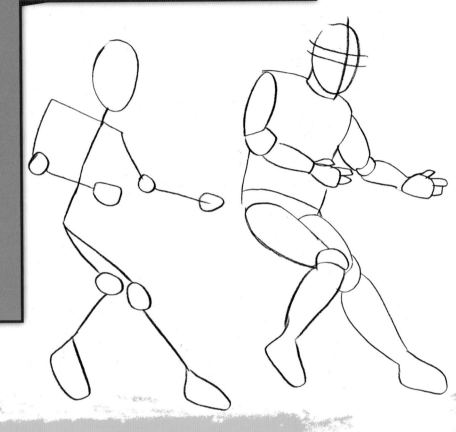

1 Draw Khalil backing somebody down in the post. Draw his body low to the ground with legs bent because he's pushing his body backward. Since he's in an active position, most of his body parts should be moving. Bend his arms and legs and twist his waist to signify motion.

2 Since Khalil is an athlete he will be fit, but don't make him too bulky. Leave both his hands open because he will need to hold the ball on either hand. Bend his right leg for leverage and keep the other straight.
Draw guidelines for his facial-features.

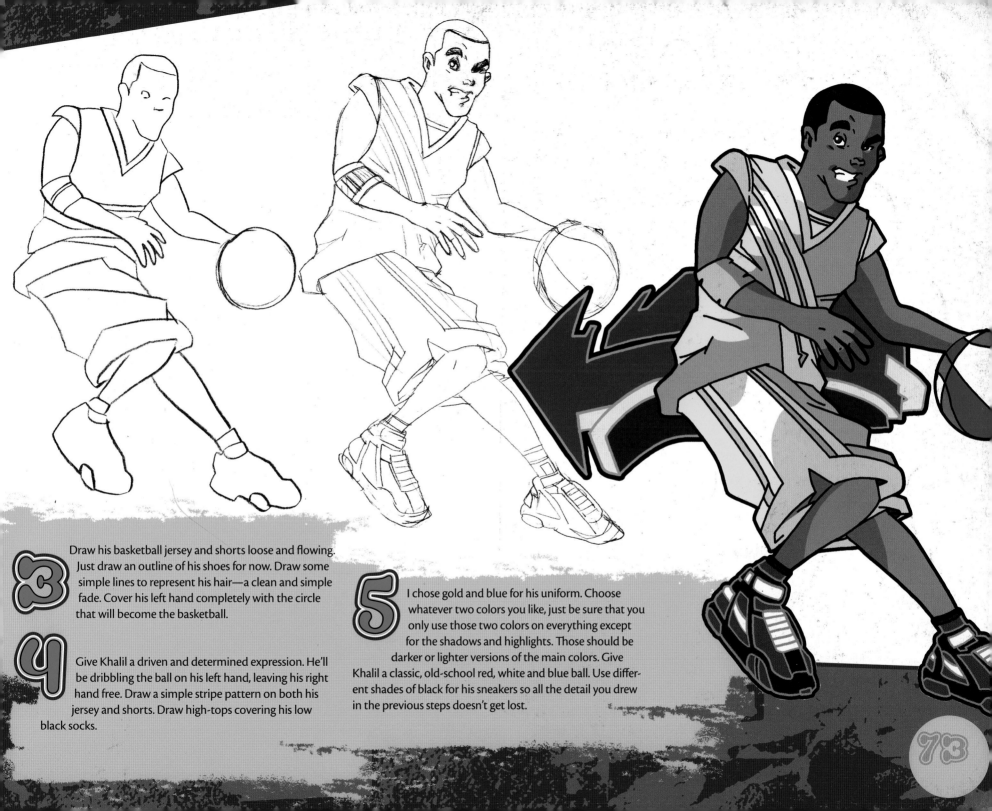

3 Draw his basketball jersey and shorts loose and flowing. Just draw an outline of his shoes for now. Draw some simple lines to represent his hair—a clean and simple fade. Cover his left hand completely with the circle that will become the basketball.

4 Give Khalil a driven and determined expression. He'll be dribbling the ball on his left hand, leaving his right hand free. Draw a simple stripe pattern on both his jersey and shorts. Draw high-tops covering his low black socks.

5 I chose gold and blue for his uniform. Choose whatever two colors you like, just be sure that you only use those two colors on everything except for the shadows and highlights. Those should be darker or lighter versions of the main colors. Give Khalil a classic, old-school red, white and blue ball. Use different shades of black for his sneakers so all the detail you drew in the previous steps doesn't get lost.

73

BMX RIDER

TRENT :: In Trent's opinion, if he doesn't go all out, it's not worth trying at all. All those scars on his body didn't come from riding safely in the bike lane. He wants to do everything he can right now.

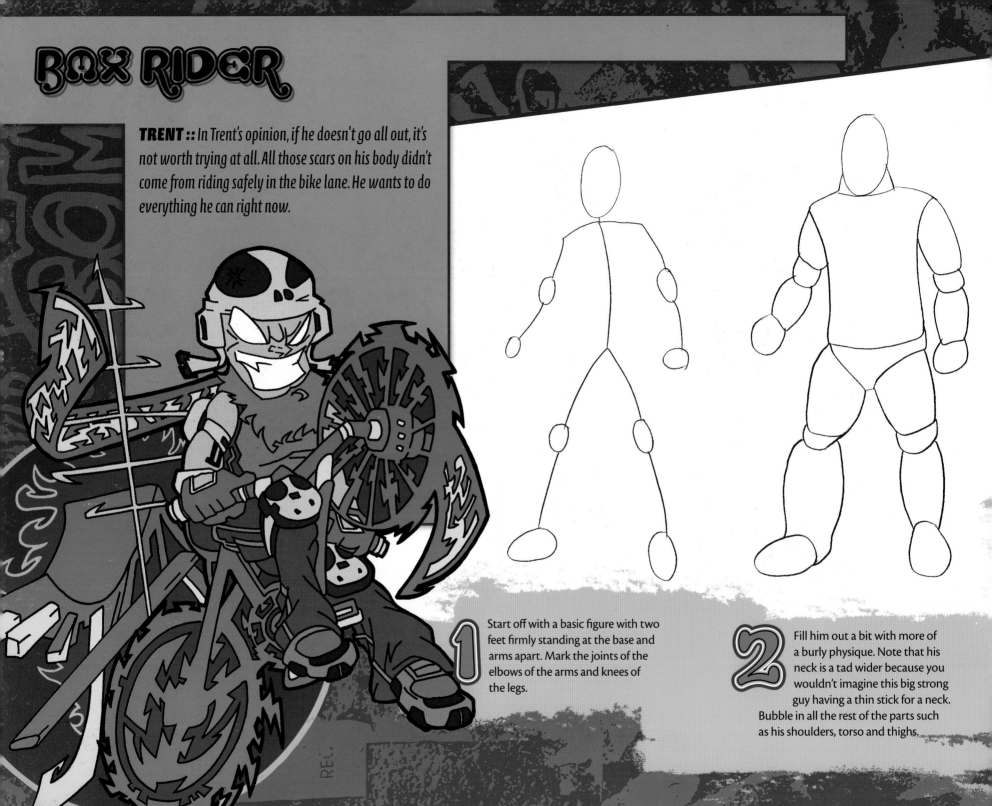

1 Start off with a basic figure with two feet firmly standing at the base and arms apart. Mark the joints of the elbows of the arms and knees of the legs.

2 Fill him out a bit with more of a burly physique. Note that his neck is a tad wider because you wouldn't imagine this big strong guy having a thin stick for a neck. Bubble in all the rest of the parts such as his shoulders, torso and thighs.

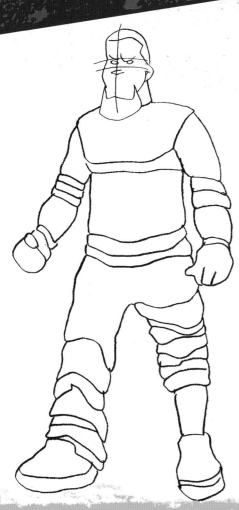
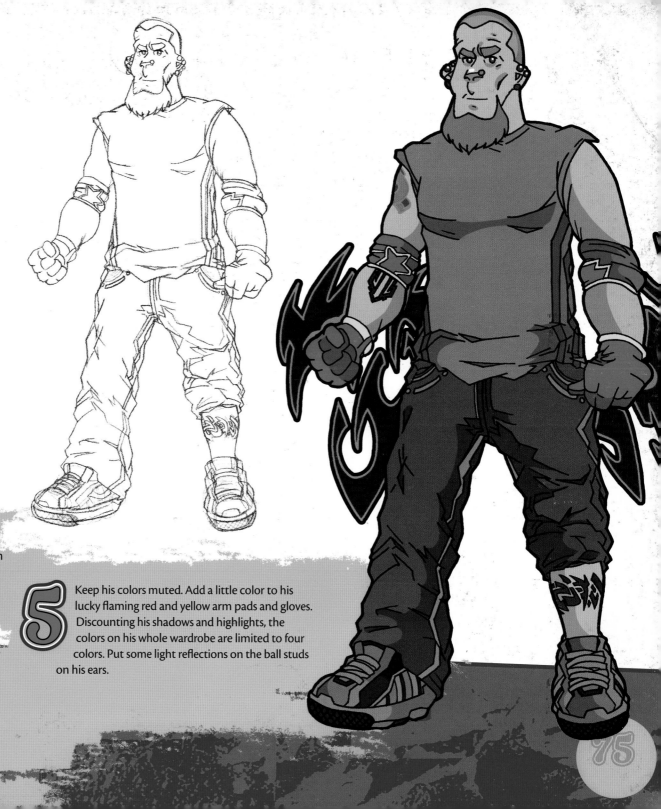

3 Begin to put in initial designs on Trent's clothes. Section off gloves and elbow pads on both arms. Plan out all the rolls and creases for his tank and jeans with his pant leg rolled up. Pay special attention to the pulled-up pant leg since it will be scrunched up more than usual.

4 Add the final details before you color. Use harsh, broken lines to define the folds in his clothing and give him a renegade look. Give him a clean, closely shaved head and use jagged lines for his beard. Draw a stud on the side of his nose and multiple earrings on his ears. Put a star emblem on both elbow pads and further refine his gloves. Give him a rugged-looking pair of sneakers.

5 Keep his colors muted. Add a little color to his lucky flaming red and yellow arm pads and gloves. Discounting his shadows and highlights, the colors on his whole wardrobe are limited to four colors. Put some light reflections on the ball studs on his ears.

SNOWBOARDER | MALE

DIXON :: First introduced to snowboarding by his dad, now you can barely get Dixon to leave the slopes. Whether you call him a free spirit or a loose cannon, there's no denying he's a star on the ice.

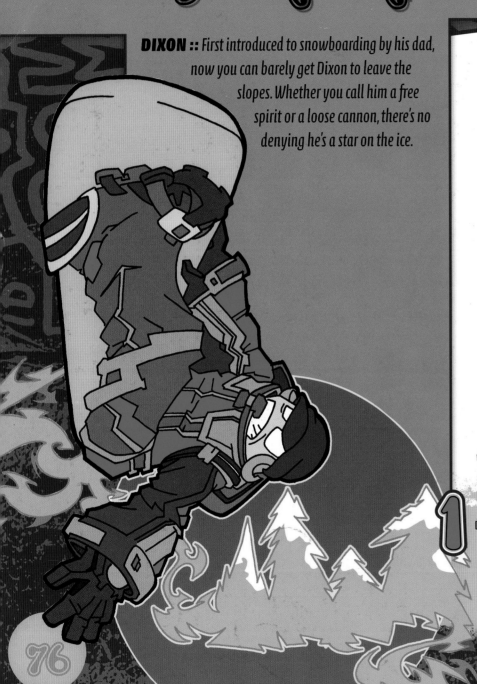

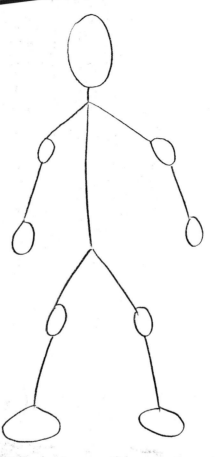

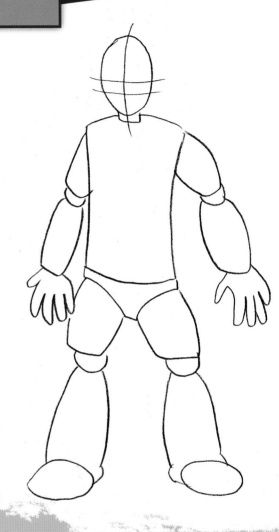

1 Draw a regular standing pose with his arms and legs spread a bit apart because he'll be wearing an oversized snowboard jacket and pants. Give him an average height.

2 Bubble in Dixon's body parts, taking into account where the joints bend on his arms and legs. Since his coat and pants are going to be oversized, you don't have to worry about making the bubble model reflect that at this stage of the drawing. Leave the hands a little oversized because they will eventually have gloves on.

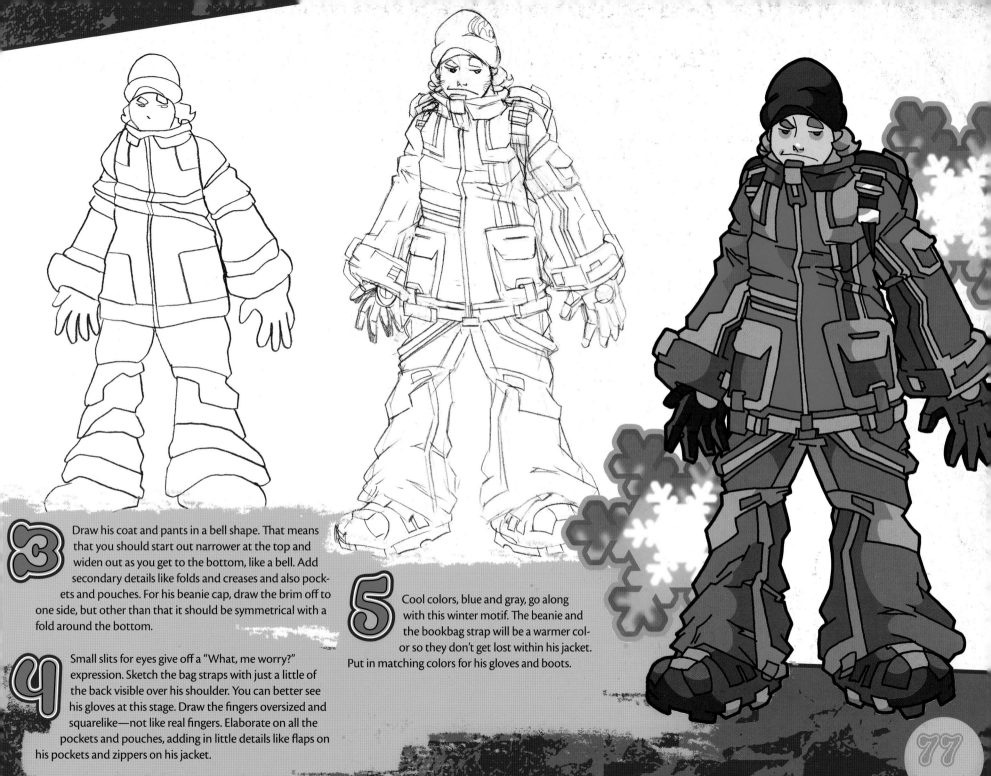

3 Draw his coat and pants in a bell shape. That means that you should start out narrower at the top and widen out as you get to the bottom, like a bell. Add secondary details like folds and creases and also pockets and pouches. For his beanie cap, draw the brim off to one side, but other than that it should be symmetrical with a fold around the bottom.

4 Small slits for eyes give off a "What, me worry?" expression. Sketch the bag straps with just a little of the back visible over his shoulder. You can better see his gloves at this stage. Draw the fingers oversized and squarelike—not like real fingers. Elaborate on all the pockets and pouches, adding in little details like flaps on his pockets and zippers on his jacket.

5 Cool colors, blue and gray, go along with this winter motif. The beanie and the bookbag strap will be a warmer color so they don't get lost within his jacket. Put in matching colors for his gloves and boots.

SNOWBOARDER | FEMALE

BEULAH :: *Like many others, Beulah loves the peace of mind that snowboarding gives her. What separates Beulah from you and me is that she has the ability to pull off back-to-back 720s and finish it off with a frontside 900 on the superpipe after her ride down the slope. She was always fascinated with surfing when she was a kid, but all Beulah had around her were snow-capped mountains. So she improvised.*

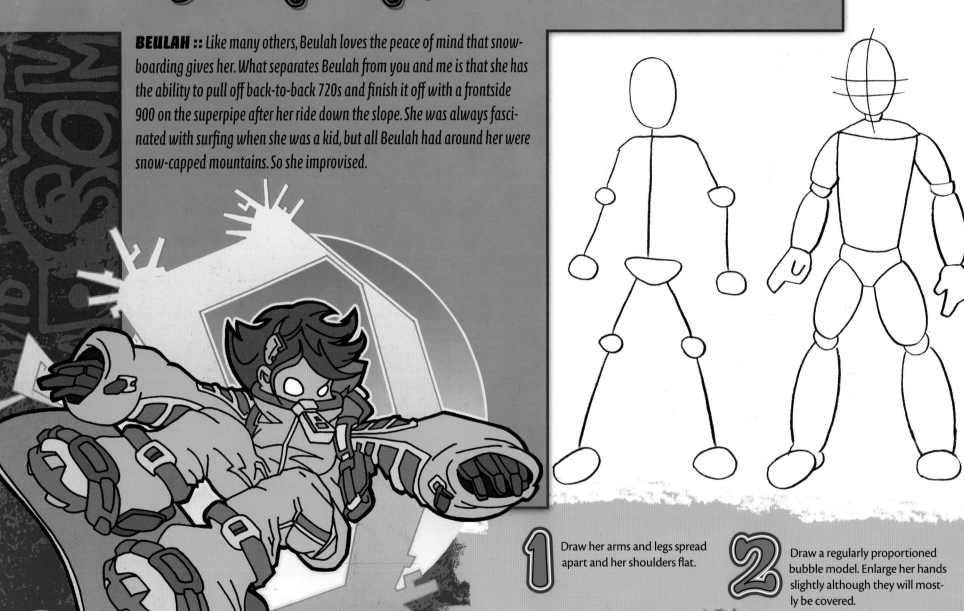

1 Draw her arms and legs spread apart and her shoulders flat.

2 Draw a regularly proportioned bubble model. Enlarge her hands slightly although they will mostly be covered.

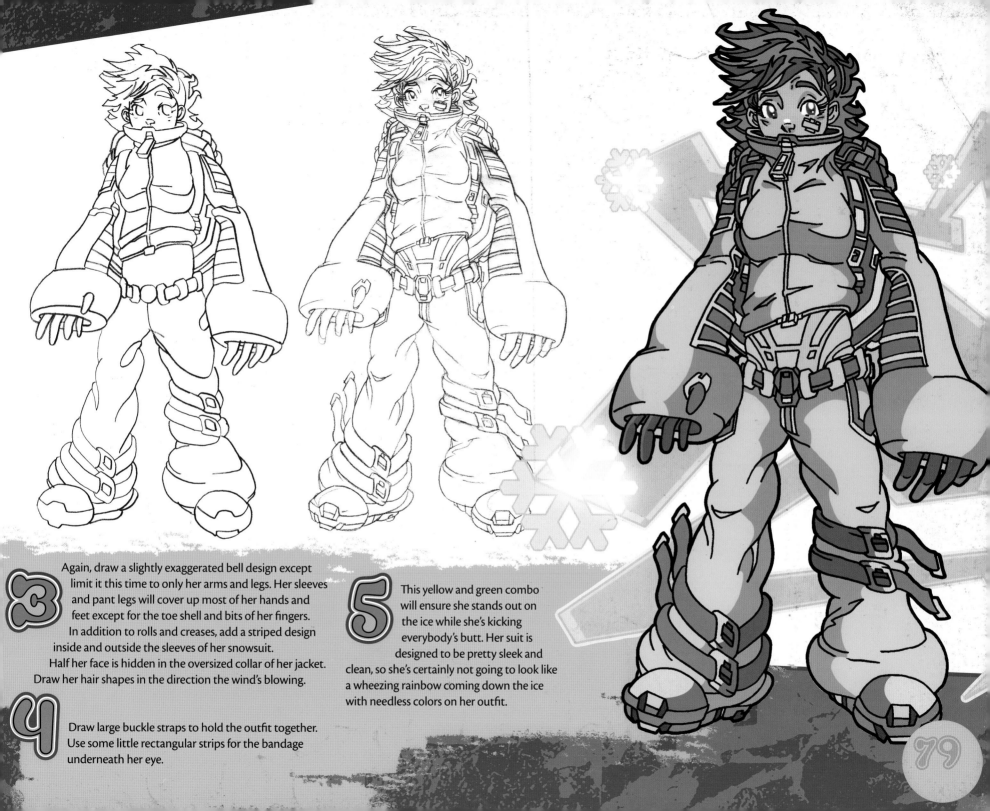

3 Again, draw a slightly exaggerated bell design except limit it this time to only her arms and legs. Her sleeves and pant legs will cover up most of her hands and feet except for the toe shell and bits of her fingers. In addition to rolls and creases, add a striped design inside and outside the sleeves of her snowsuit.
Half her face is hidden in the oversized collar of her jacket. Draw her hair shapes in the direction the wind's blowing.

4 Draw large buckle straps to hold the outfit together. Use some little rectangular strips for the bandage underneath her eye.

5 This yellow and green combo will ensure she stands out on the ice while she's kicking everybody's butt. Her suit is designed to be pretty sleek and clean, so she's certainly not going to look like a wheezing rainbow coming down the ice with needless colors on her outfit.

GOTH GIRL

MARTA :: Other girls think she's strange, but the thing Marta enjoys about being herself is that she doesn't care. It was never her thing to follow the crowd, and as long as Marta keeps marking her own path, she has nothing to worry about.

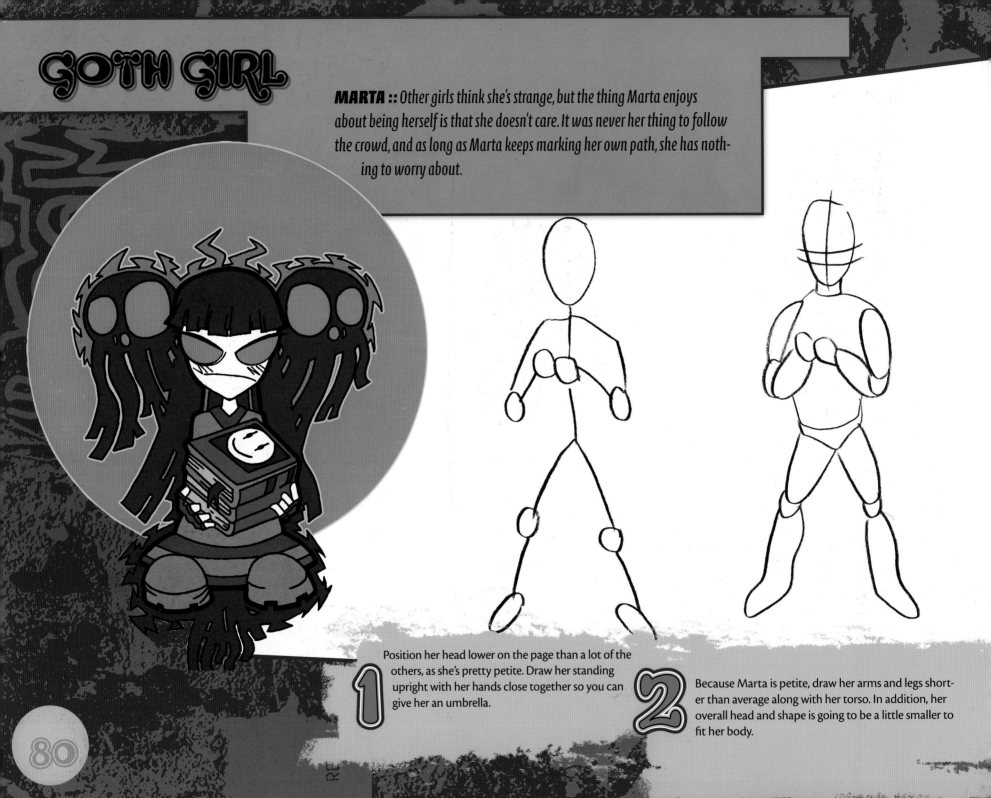

1 Position her head lower on the page than a lot of the others, as she's pretty petite. Draw her standing upright with her hands close together so you can give her an umbrella.

2 Because Marta is petite, draw her arms and legs shorter than average along with her torso. In addition, her overall head and shape is going to be a little smaller to fit her body.

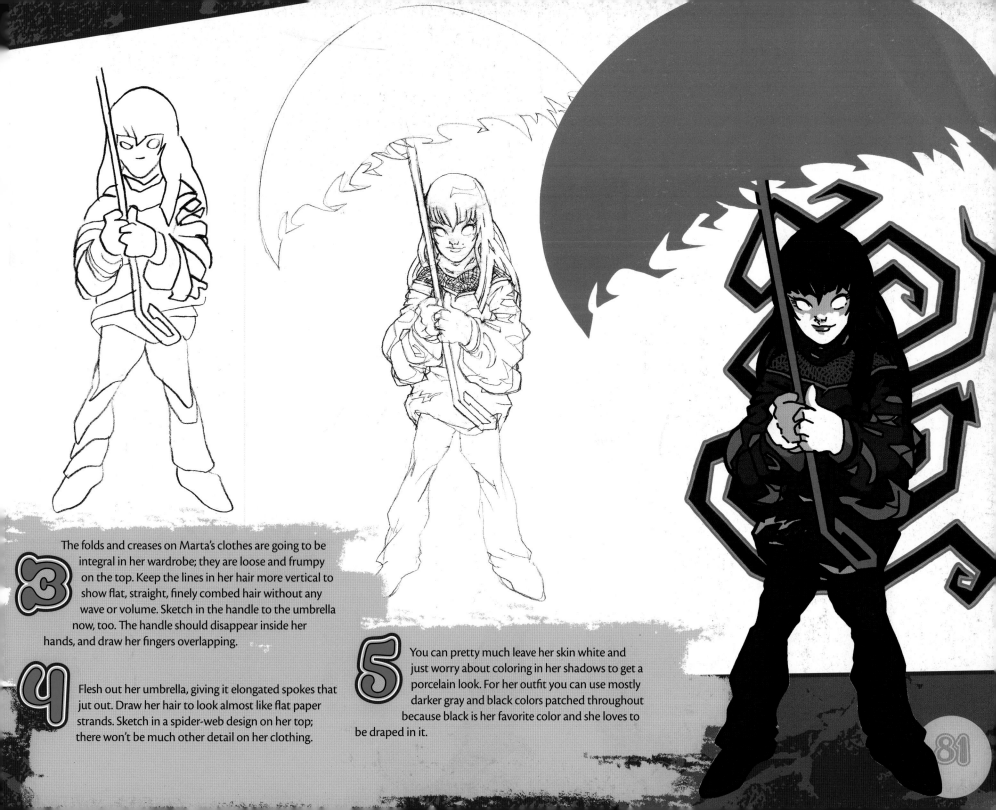

The folds and creases on Marta's clothes are going to be integral in her wardrobe; they are loose and frumpy on the top. Keep the lines in her hair more vertical to show flat, straight, finely combed hair without any wave or volume. Sketch in the handle to the umbrella now, too. The handle should disappear inside her hands, and draw her fingers overlapping.

Flesh out her umbrella, giving it elongated spokes that jut out. Draw her hair to look almost like flat paper strands. Sketch in a spider-web design on her top; there won't be much other detail on her clothing.

You can pretty much leave her skin white and just worry about coloring in her shadows to get a porcelain look. For her outfit you can use mostly darker gray and black colors patched throughout because black is her favorite color and she loves to be draped in it.

81

COOL GIRL

AVA :: The penultimate overachiever, of course Ava's not only the cute girl in school but also president, captain of the debate team, has an exceptional grade average—AND she recycles.

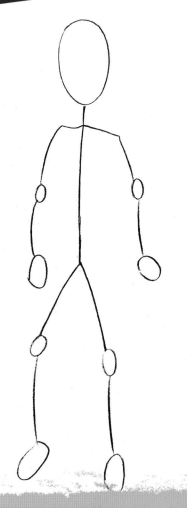

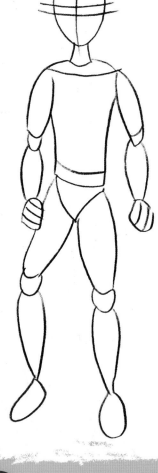

1 Start off with a basic stick figure. Indicate the joints with circles and make one arm and one leg bent a little to indicate movement. Make her petite. Even though her leg is bent a little, balance her out so she doesn't look like she's standing on one leg. Point her toes downward because she's going to be wearing heels.

2 Flesh out all her body parts by adding the bubble form. Draw her chest and torso narrow along with her arms and legs. Just draw some rough lines for fingers. Place the eye and nose lines as they will determine their placement later on.

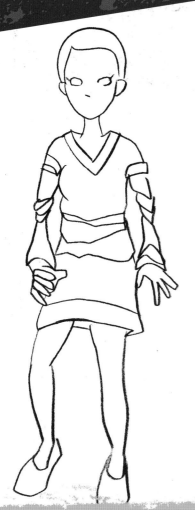

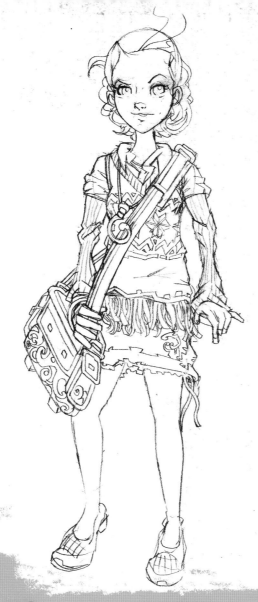

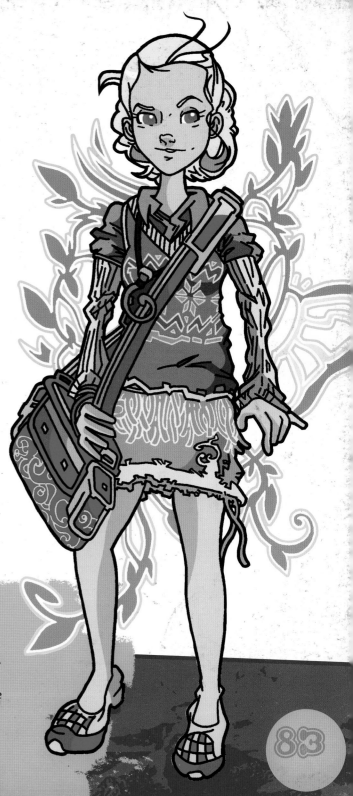

3 Add her long skirt and sleeves as well as some folds and creases. Think of the bubble model as a lump of clay that you are shaping. If you think a crease and a wrinkle should go somewhere, pretend you're cutting off or adding a piece of the previous bubble. Draw her fingers in one hand as if she is gripping something. Rough in her eyes and nose. Give her a skirt and a sweater vest. Cover her arms with chunky long sleeves.

4 Draw a couple of loose strands around the top of Ava's hair and add some curly lines around the nape of her neck. A slight smile, big eyes and an arched eyebrow give her a confident look. Draw bunched short sleeves over the longer-sleeved stripes to give her a layered look. Add a single strap messenger bag where she keeps all her school stuff. Make her skirt look frilly by drawing in lines to make it look as if it's been cut with scissors.

5 Use bright, vibrant colors. Use different colors for the patterns on her sweater and her bookbag. Add shadows using darker shades of each color. Make her top a bluish pink hue and her skirt a yellow-green hue for some color contrast. Her shoes and her bag will combine those two shades together to create a checkerboard design for her shoes and sea wave design on her bag.

COOL GUY

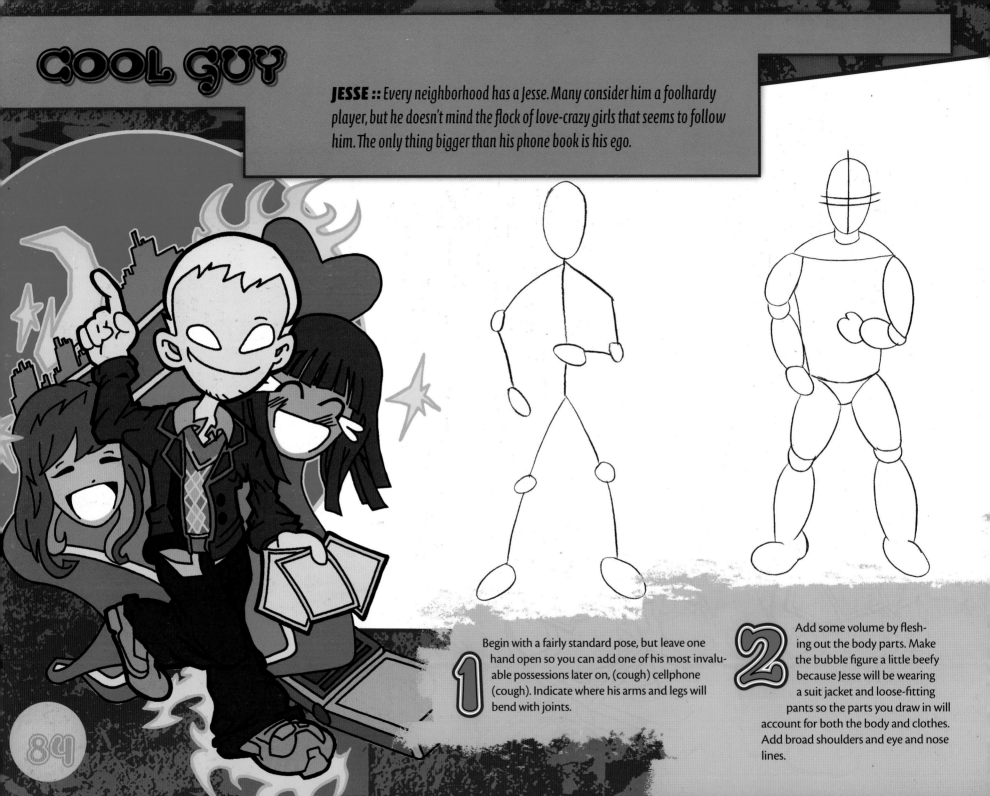

JESSE :: *Every neighborhood has a Jesse. Many consider him a foolhardy player, but he doesn't mind the flock of love-crazy girls that seems to follow him. The only thing bigger than his phone book is his ego.*

1 Begin with a fairly standard pose, but leave one hand open so you can add one of his most invaluable possessions later on, (cough) cellphone (cough). Indicate where his arms and legs will bend with joints.

2 Add some volume by fleshing out the body parts. Make the bubble figure a little beefy because Jesse will be wearing a suit jacket and loose-fitting pants so the parts you draw in will account for both the body and clothes. Add broad shoulders and eye and nose lines.

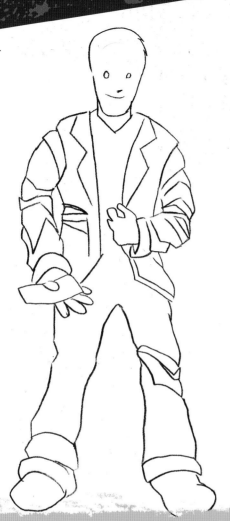

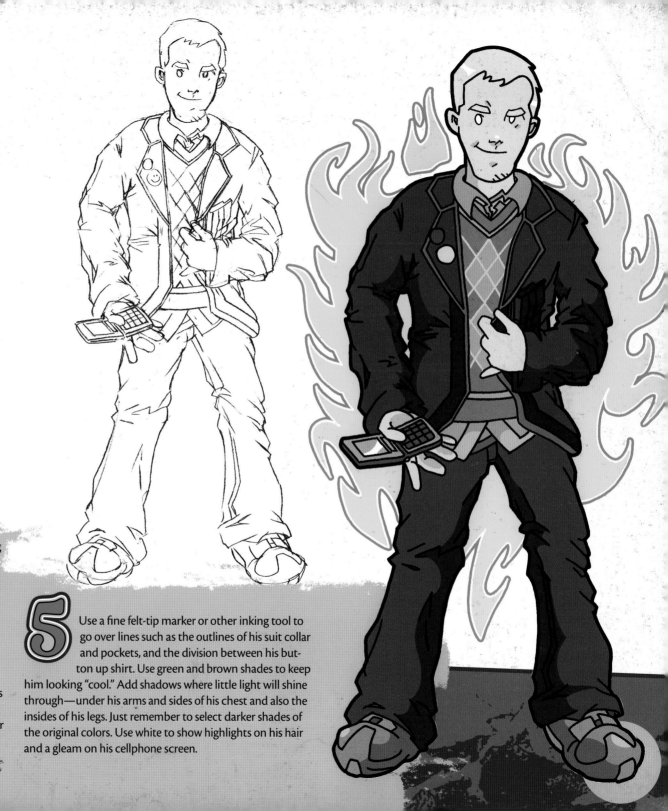

3 Give his suit and pants some wrinkles and creases by cutting off small sections of the bubble part. Spots where his arms and legs bend and where a rolled up pant leg meets the ground will have more creases. Add in his cellphone on one hand and make his other hand pop the collar of his suit, further giving him a cocky demeanor. Leave some room inside his suit for now.

4 Put a confident smirk on his face. Draw in details of his suit such as the pocket on his jacket and the button pins on his collar. Inside his suit, add an argyle sweater and add some wrinkles to his pants. Give him some shoes and a short-cropped haircut.

5 Use a fine felt-tip marker or other inking tool to go over lines such as the outlines of his suit collar and pockets, and the division between his button up shirt. Use green and brown shades to keep him looking "cool." Add shadows where little light will shine through—under his arms and sides of his chest and also the insides of his legs. Just remember to select darker shades of the original colors. Use white to show highlights on his hair and a gleam on his cellphone screen.

THE TALKER

GENNA :: Genna loves talking on the phone every night—she's got to keep in touch. She also has to find out if Derek's going to finally ask her out. She has all her friends working as snoops to see what he's thinking.

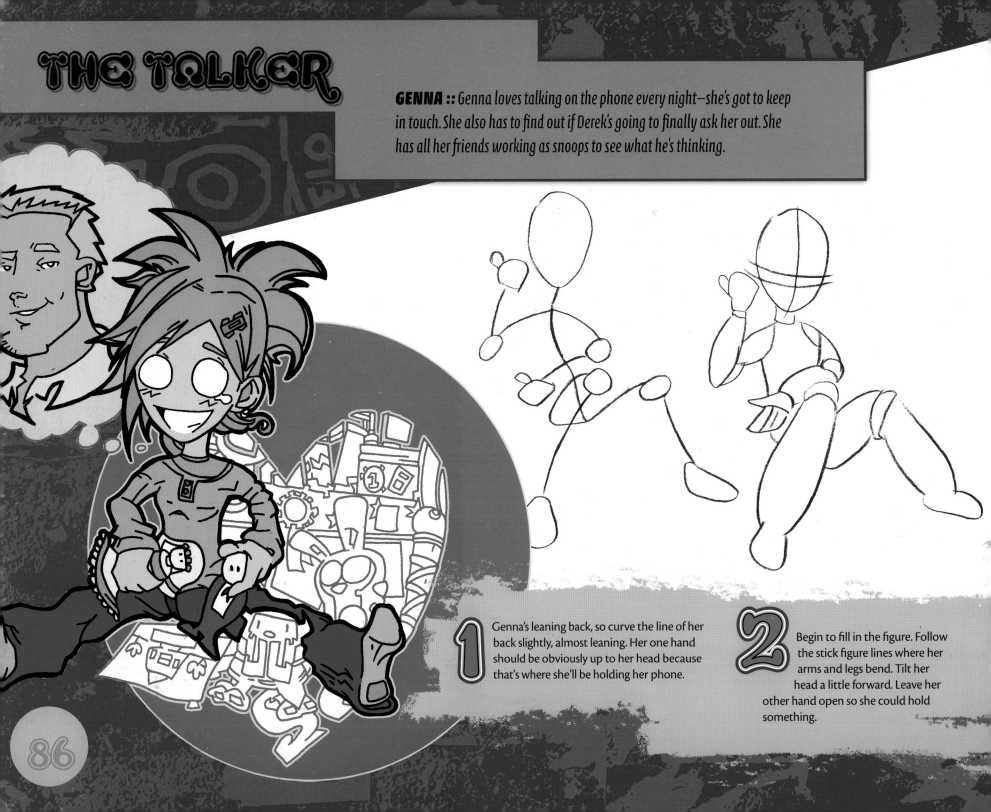

1 Genna's leaning back, so curve the line of her back slightly, almost leaning. Her one hand should be obviously up to her head because that's where she'll be holding her phone.

2 Begin to fill in the figure. Follow the stick figure lines where her arms and legs bend. Tilt her head a little forward. Leave her other hand open so she could hold something.

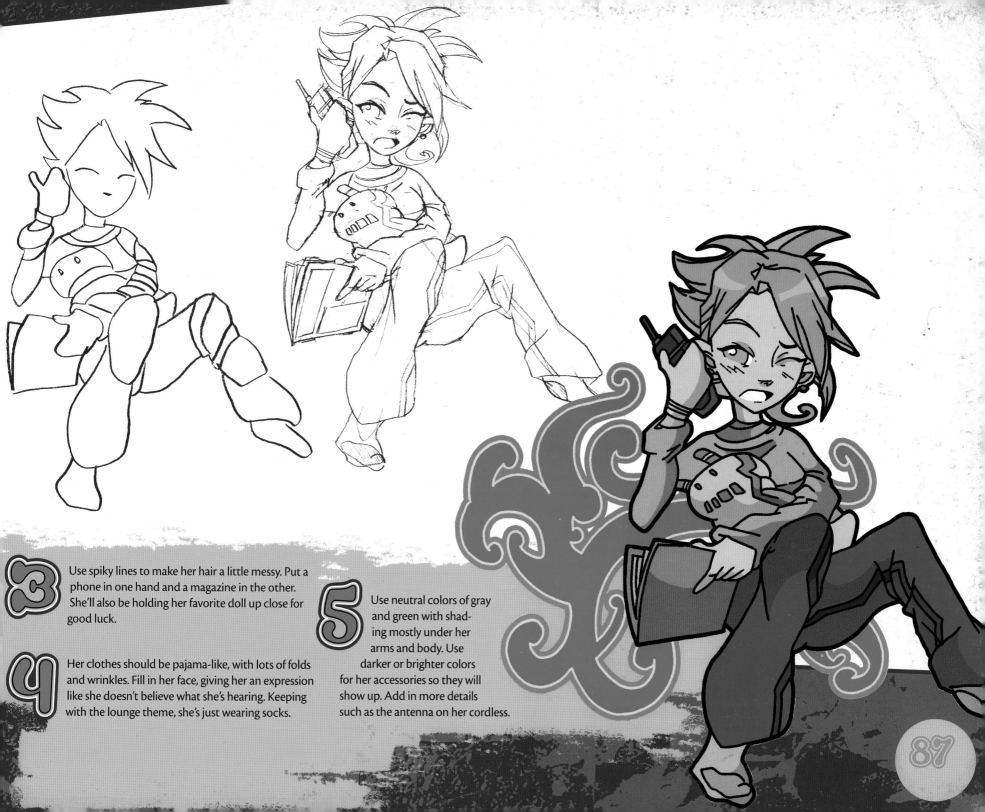

3 Use spiky lines to make her hair a little messy. Put a phone in one hand and a magazine in the other. She'll also be holding her favorite doll up close for good luck.

4 Her clothes should be pajama-like, with lots of folds and wrinkles. Fill in her face, giving her an expression like she doesn't believe what she's hearing. Keeping with the lounge theme, she's just wearing socks.

5 Use neutral colors of gray and green with shading mostly under her arms and body. Use darker or brighter colors for her accessories so they will show up. Add in more details such as the antenna on her cordless.

FASHIONISTA

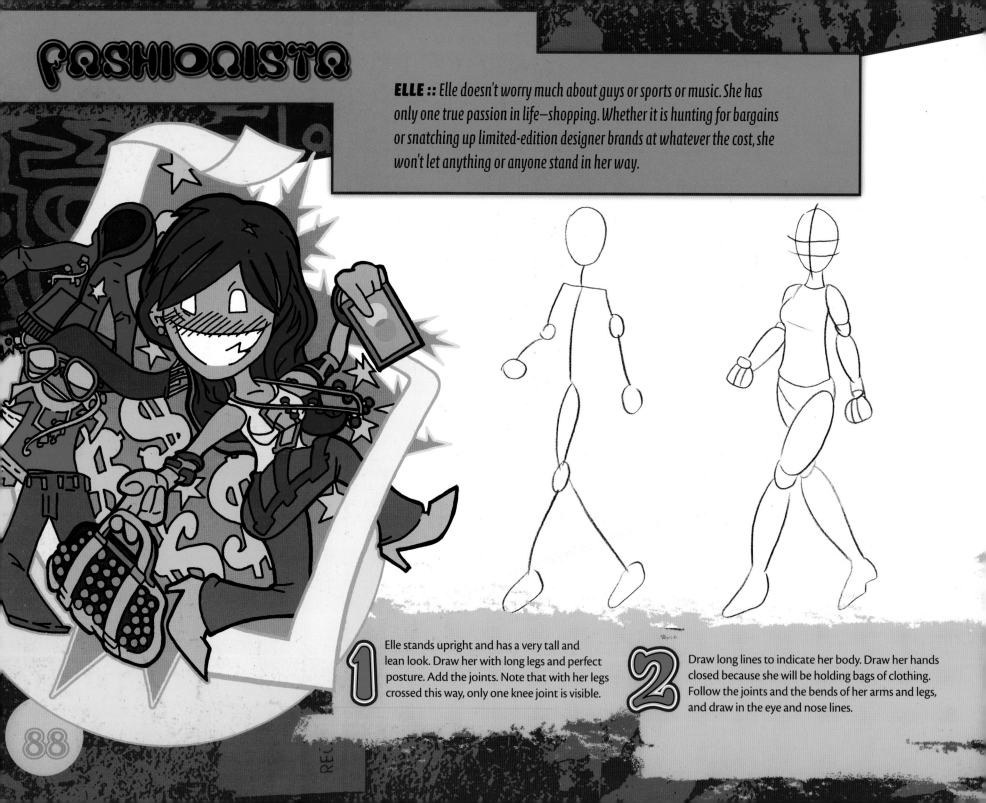

ELLE :: Elle doesn't worry much about guys or sports or music. She has only one true passion in life—shopping. Whether it is hunting for bargains or snatching up limited-edition designer brands at whatever the cost, she won't let anything or anyone stand in her way.

1 Elle stands upright and has a very tall and lean look. Draw her with long legs and perfect posture. Add the joints. Note that with her legs crossed this way, only one knee joint is visible.

2 Draw long lines to indicate her body. Draw her hands closed because she will be holding bags of clothing. Follow the joints and the bends of her arms and legs, and draw in the eye and nose lines.

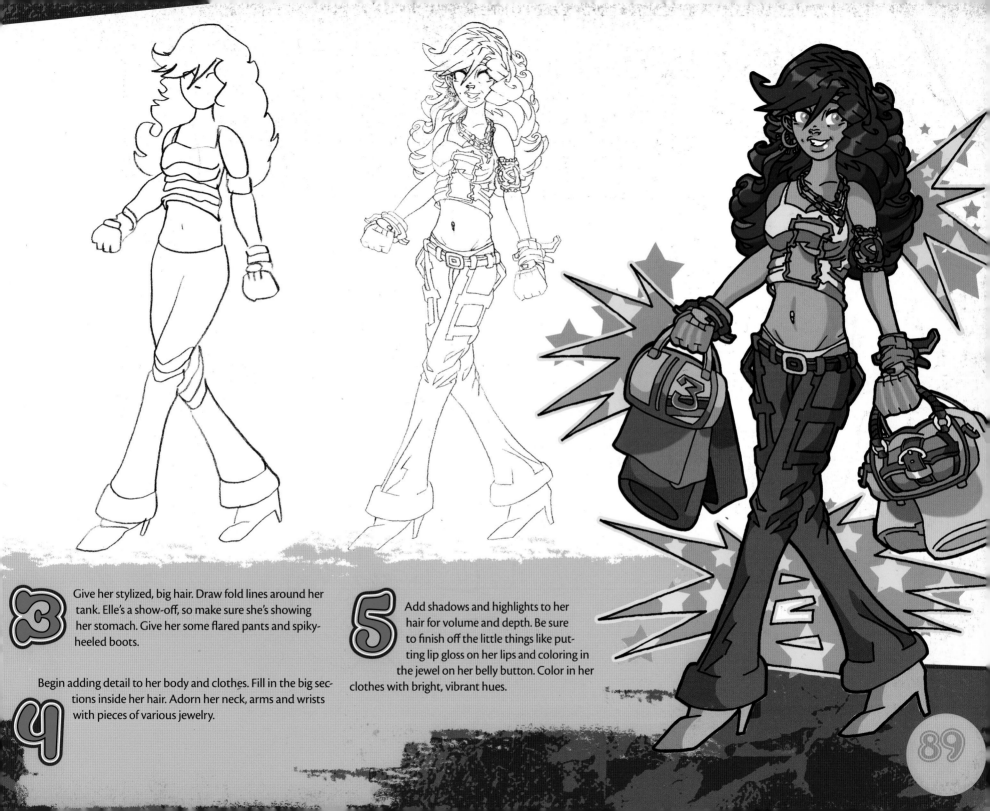

3 Give her stylized, big hair. Draw fold lines around her tank. Elle's a show-off, so make sure she's showing her stomach. Give her some flared pants and spiky-heeled boots.

4 Begin adding detail to her body and clothes. Fill in the big sections inside her hair. Adorn her neck, arms and wrists with pieces of various jewelry.

5 Add shadows and highlights to her hair for volume and depth. Be sure to finish off the little things like putting lip gloss on her lips and coloring in the jewel on her belly button. Color in her clothes with bright, vibrant hues.

89

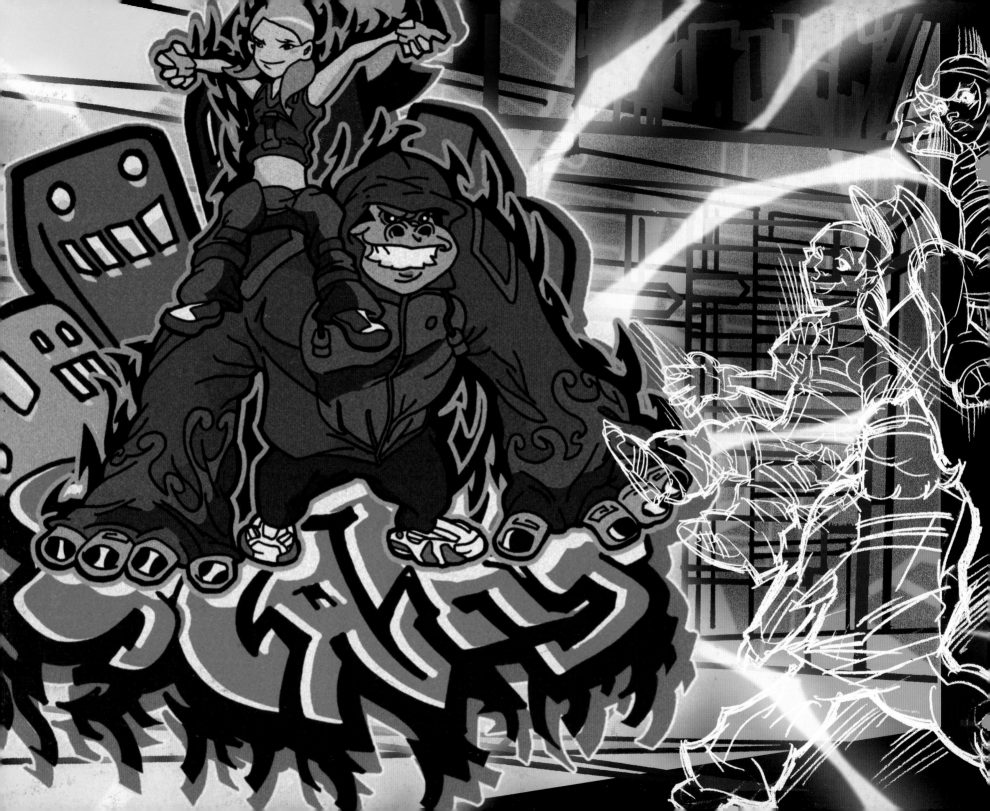

BACKGROUNDS & SCENES

Outdoor Backgrounds

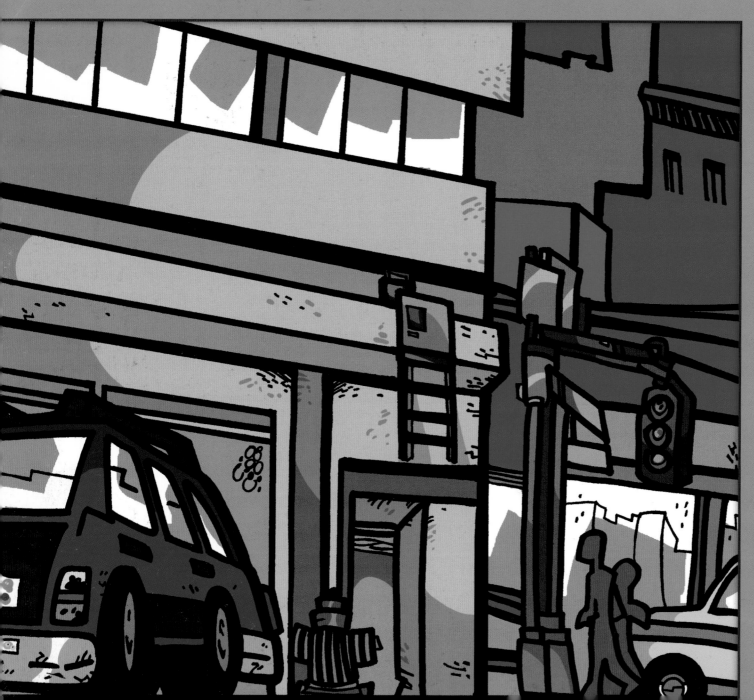

For every background, think first about the main big shapes you want to use. Angular shapes with a lot of hard outlines add an edgy look to most work. Similarly hued colors feed and work with one another. I find too many different colors give me a rainbow look that I don't like.

COLORING BACKGROUNDS

Using a limited palette for your backgrounds (four or five colors tops) allows any characters you use to stand out more. Divide your color combinations into cools (blues, violets) and warms (reds, yellows).

STREET SCENES

Pack street scenes with lots of activity. You notice that besides the buildings there are other elements you can draw such as the various cars on the street, the fire hydrant on the ground, the street post, and the traffic light. As you draw your backgrounds, remember that objects closer to the viewer will be larger. The car on the left appears closer than the car on the right because of its location and placement.

Car on the Left

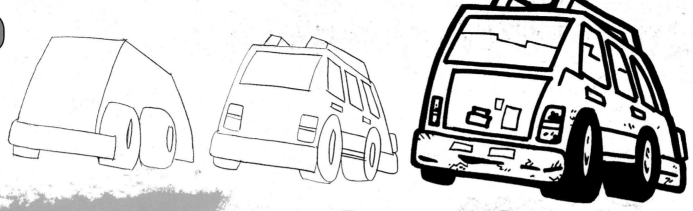

 Draw the car shapes from the back. You can only see the wheels from one side.

 Fill in the windows, doors and taillights. Round out the wheels.

3 Darken the pencils. Add a little dirt and wear on the car for realism.

Streetlight With People

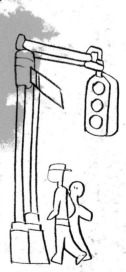

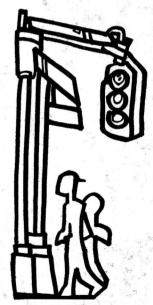

1 Draw the shapes that make this part of the scene—they're ultra-simple.

2 Darken the lines and you're set.

Fire Hydrant

 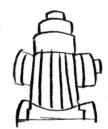 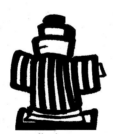

1 Draw the hydrant mainly as a cylinder with circles sticking out of it.

 Add the line designs.

 Just outline the completed design and you're finished. You can add color directly on top of the piece.

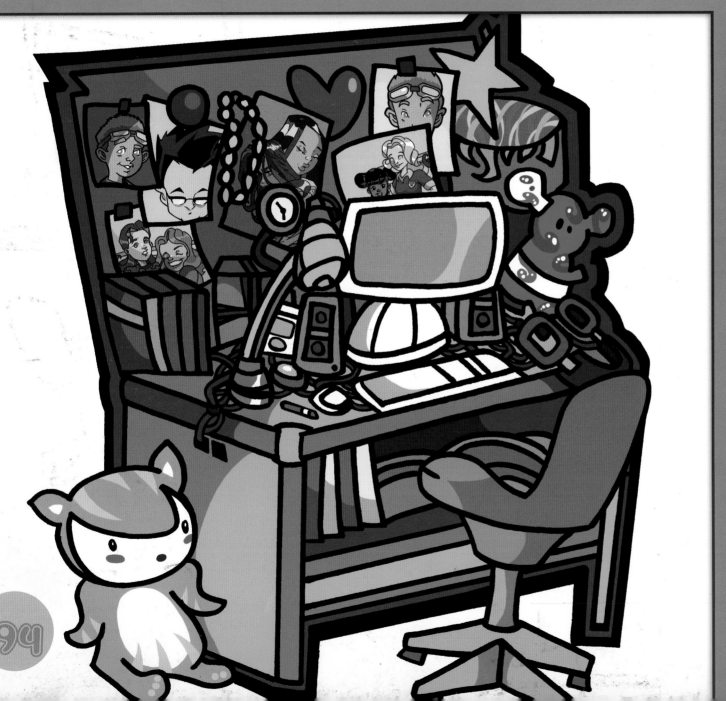

In an interior setting, objects can be packed in more closely and tightly to give the feeling that you are inside and concentrating on one area.

CLOSE-UP INDOOR SCENES
For these sorts of backgrounds, begin with the major elements or parts of the picture that you most want to highlight. What those are is really up to you.

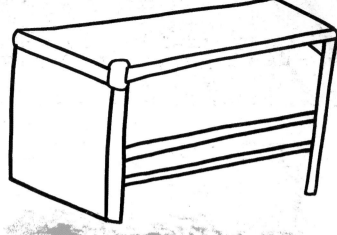

 Start with a three-dimensional rectangle with the bottom section cut out.

 Put in shelves on the bottom and separate the desk into two parts.

 Outline it just so you can easily identify the different parts, such as the top board on the desk, the side panels for support and the shelves.

Chair

Computer

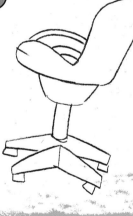
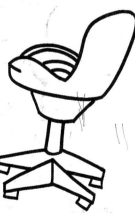

 Draw the computer as three shapes: a wide rectangle, a narrow rectangle and a half cube.

 Add circular, wavy lines on the half cube to show that it's round, and you're ready to add some color.

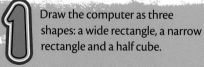 Add a screen to the upper rectangle and separate the lines from the keyboard for the lower rectangle.

 This is a side view of the chair, so adjust the perspective of the shapes accordingly.

 Fill in the seat's circular shape so it looks like the seat goes all the way around.

 Separate the legs into four pieces and add the armrests.

 95

MORE INTERIORS

Most of the backgrounds you'll use will be long shots showing larger spaces. It's not any more difficult to draw though—you're still just arranging shapes.

BEDROOM

This bedroom is a little messy with clothes flung on the bed and sheets of paper on the floor. But it's a good lesson in how placing objects at different depths can make a picture more interesting like putting a drawer to the side of the room and also putting one far off into the distance at the right.

BEGIN WITH THE MAJOR ELEMENTS

Again, even though this is a wide interior, begin with the major elements such as the bed, drawer, dresser and drapes. From there you can begin to embellish with things like the poster, clothes on the bed, the laundry basket and the alarm clock.

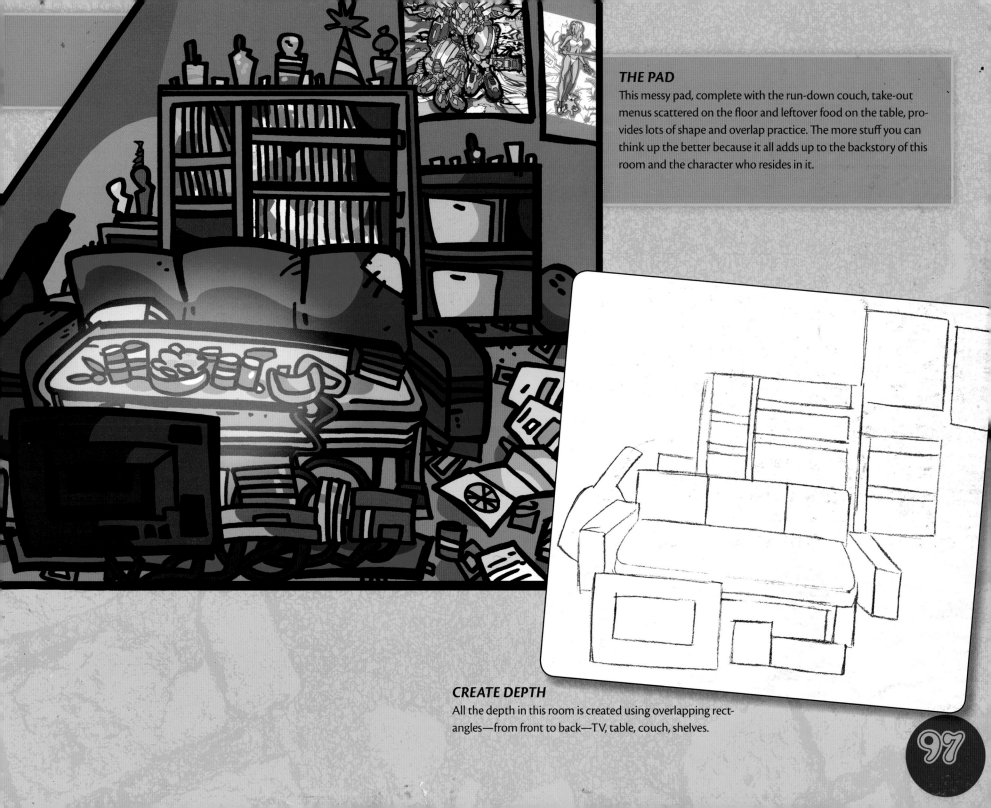

THE PAD

This messy pad, complete with the run-down couch, take-out menus scattered on the floor and leftover food on the table, provides lots of shape and overlap practice. The more stuff you can think up the better because it all adds up to the backstory of this room and the character who resides in it.

CREATE DEPTH

All the depth in this room is created using overlapping rectangles—from front to back—TV, table, couch, shelves.

Abstract Background I

Most of the backgrounds I use are abstract—they're not constrained by the rules of realism. Abstract backgrounds should still come from a real foundation, though. Ideally, you combine basic drawing concepts with your own inventions to create a style you can call your own. You don't have to draw everything with perfectly straight lines and correct angles. But, you do want to begin with realistic items and work from there.

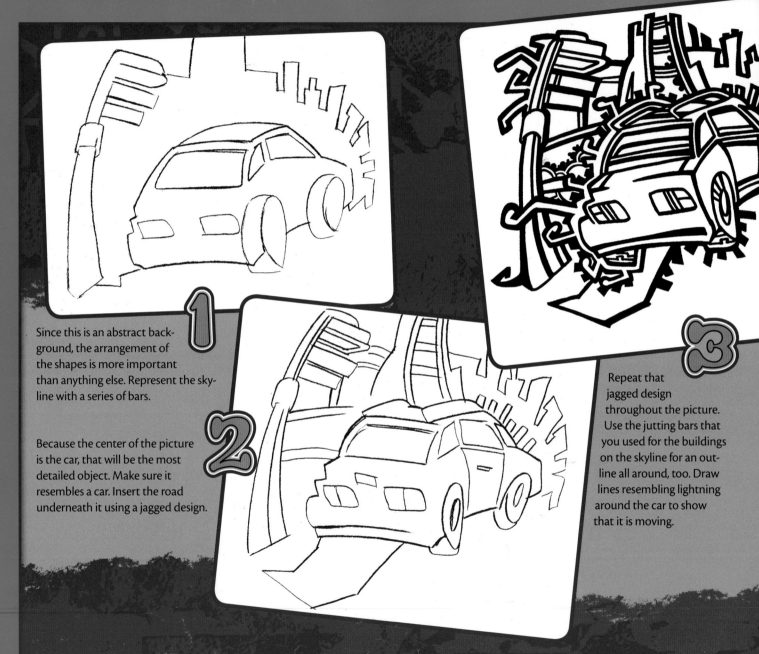

Since this is an abstract background, the arrangement of the shapes is more important than anything else. Represent the skyline with a series of bars.

Because the center of the picture is the car, that will be the most detailed object. Make sure it resembles a car. Insert the road underneath it using a jagged design.

Repeat that jagged design throughout the picture. Use the jutting bars that you used for the buildings on the skyline for an outline all around, too. Draw lines resembling lightning around the car to show that it is moving.

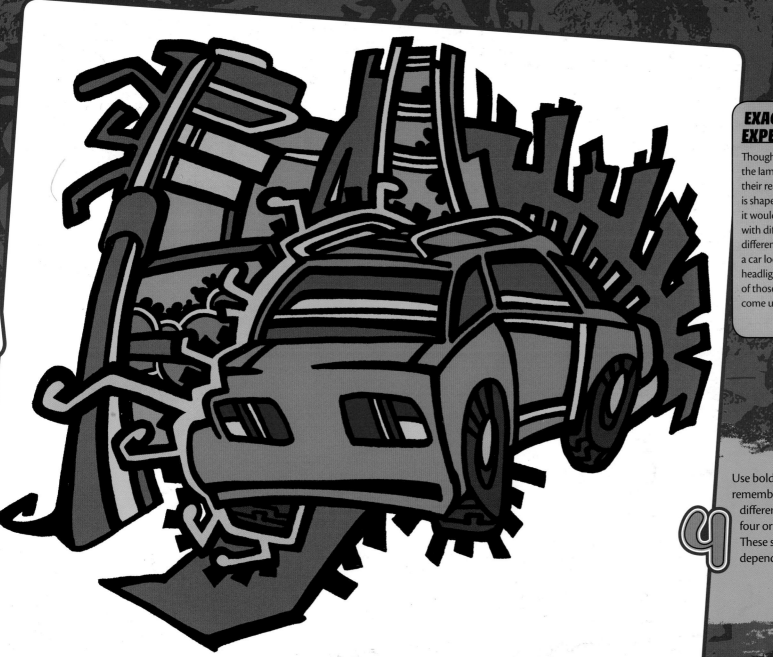

EXAGGERATE AND EXPERIMENT

Though the main objects (the car and the lamppost) somewhat resemble their realistic counterparts, the skyline is shaped and drawn far differently than it would look in reality. Experiment with different ways of interpreting different objects. We all know what a car looks like: four wheels, a hood, headlights, trunk, etc. Exaggerate one of those features and see what you can come up with.

Use bold colors for this one. Just remember not to use too many different ones. Choose a palette of four or five colors and stick to it. These sorts of backgrounds are dependent on patterns.

Abstract Background II

You can use the same techniques you used for the car on page 98 to create larger cityscapes.

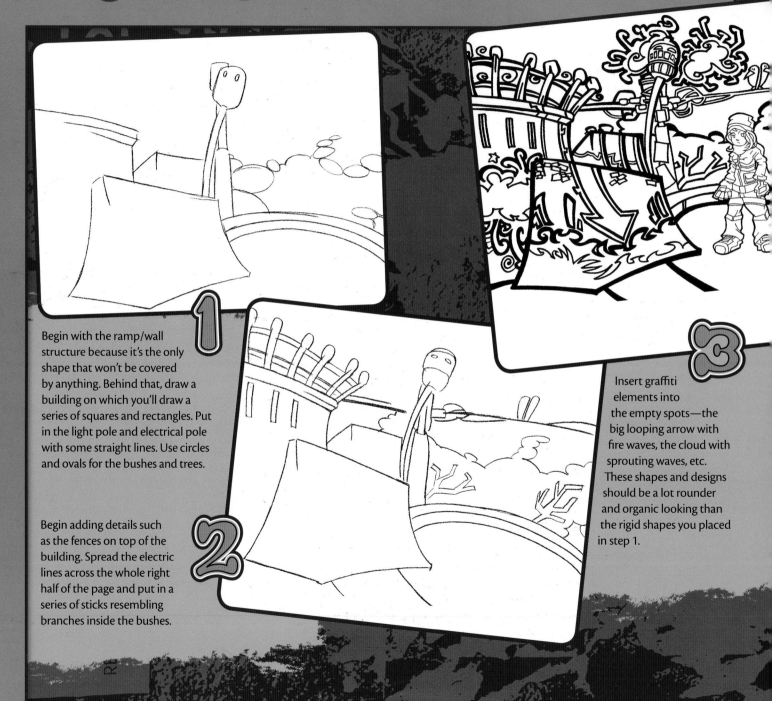

Begin with the ramp/wall structure because it's the only shape that won't be covered by anything. Behind that, draw a building on which you'll draw a series of squares and rectangles. Put in the light pole and electrical pole with some straight lines. Use circles and ovals for the bushes and trees.

Begin adding details such as the fences on top of the building. Spread the electric lines across the whole right half of the page and put in a series of sticks resembling branches inside the bushes.

Insert graffiti elements into the empty spots—the big looping arrow with fire waves, the cloud with sprouting waves, etc. These shapes and designs should be a lot rounder and organic looking than the rigid shapes you placed in step 1.

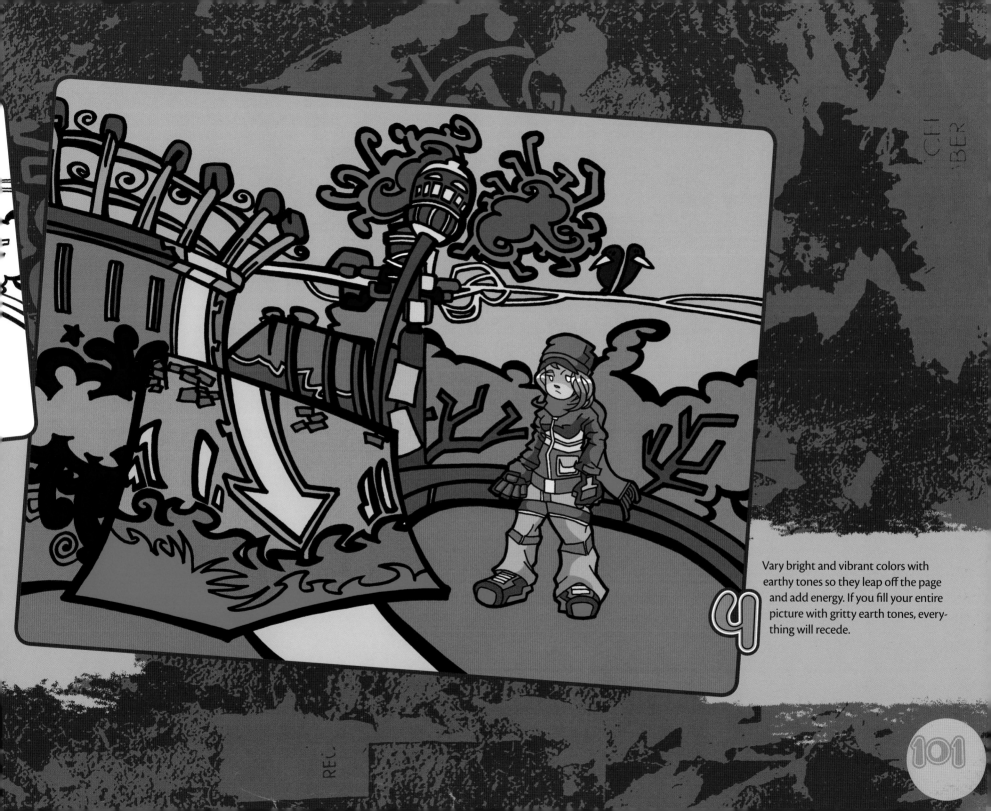

Vary bright and vibrant colors with earthy tones so they leap off the page and add energy. If you fill your entire picture with gritty earth tones, everything will recede.

Skater Background 1

Now that you've practiced a little making abstract backgrounds, let's look at some backgrounds that might fit for some of the characters from chapter 3. This first one I drew for our male skater, TJ, from page 68. I used colored construction paper for my surface for the scene.

I gave TJ some three-dimensional trail lines to show his path up the ramp. These also serve as action lines to show his major air from the ground up. Draw the lines in a different and lighter color than TJ to emphasize their role as action lines, not the actual subject of your picture.

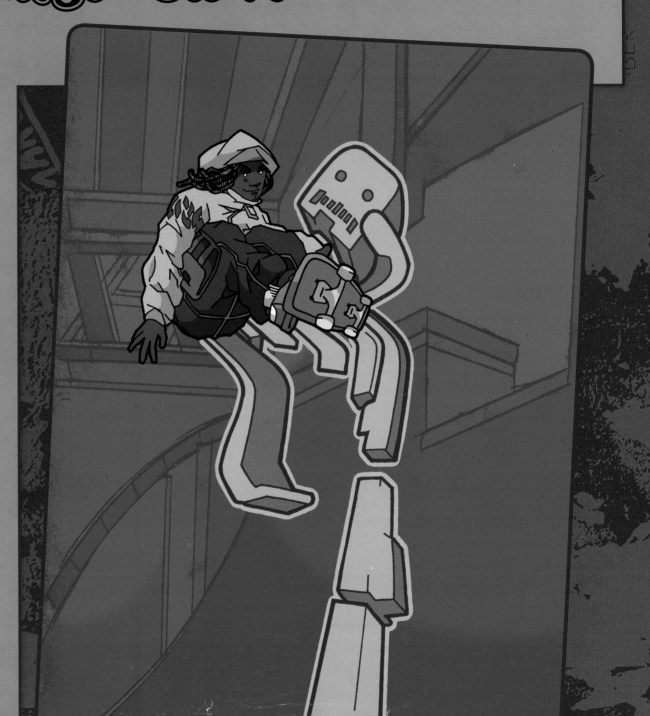

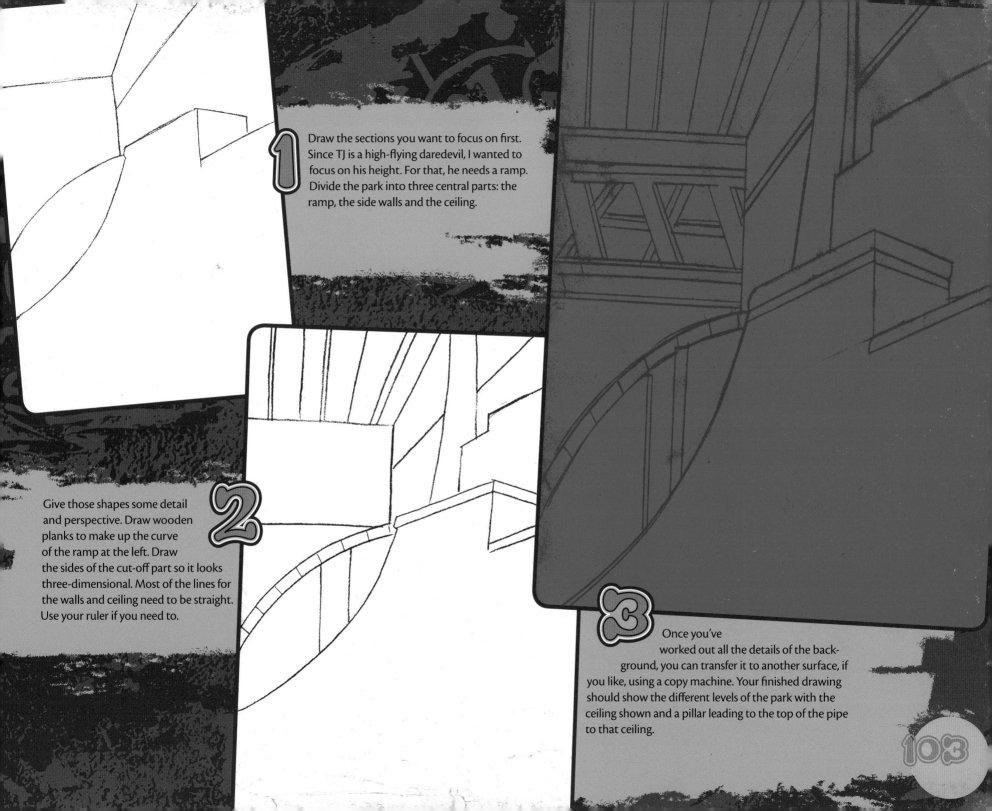

1 Draw the sections you want to focus on first. Since TJ is a high-flying daredevil, I wanted to focus on his height. For that, he needs a ramp. Divide the park into three central parts: the ramp, the side walls and the ceiling.

2 Give those shapes some detail and perspective. Draw wooden planks to make up the curve of the ramp at the left. Draw the sides of the cut-off part so it looks three-dimensional. Most of the lines for the walls and ceiling need to be straight. Use your ruler if you need to.

3 Once you've worked out all the details of the background, you can transfer it to another surface, if you like, using a copy machine. Your finished drawing should show the different levels of the park with the ceiling shown and a pillar leading to the top of the pipe to that ceiling.

103

Skater Background II

Rails are Ellie's specialty, so this background is going to be all about the rails. (She's at the end of a run, doing a kickflip off the rail.)

I followed the same color scheme as I used for her previous pose on page 70. The one final important thing is to add an additional set of lines just around her figure in the same color as her wristband and shirt collar so she pops right off her board and the page. You want to avoid any characters fading into the background.

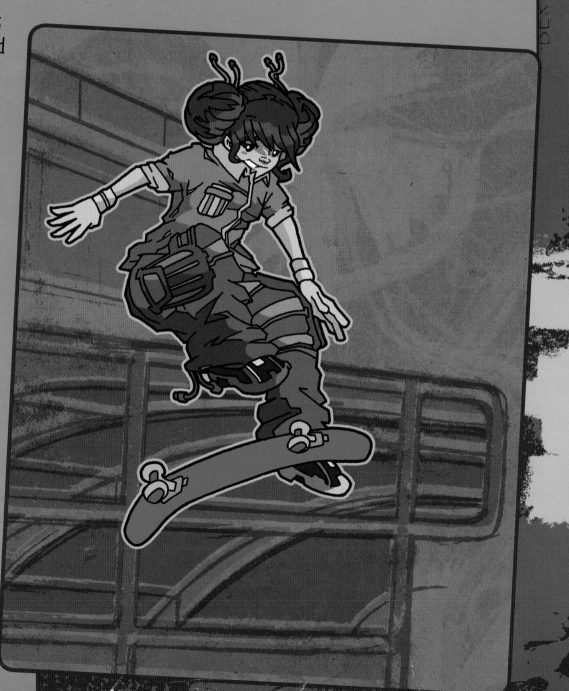

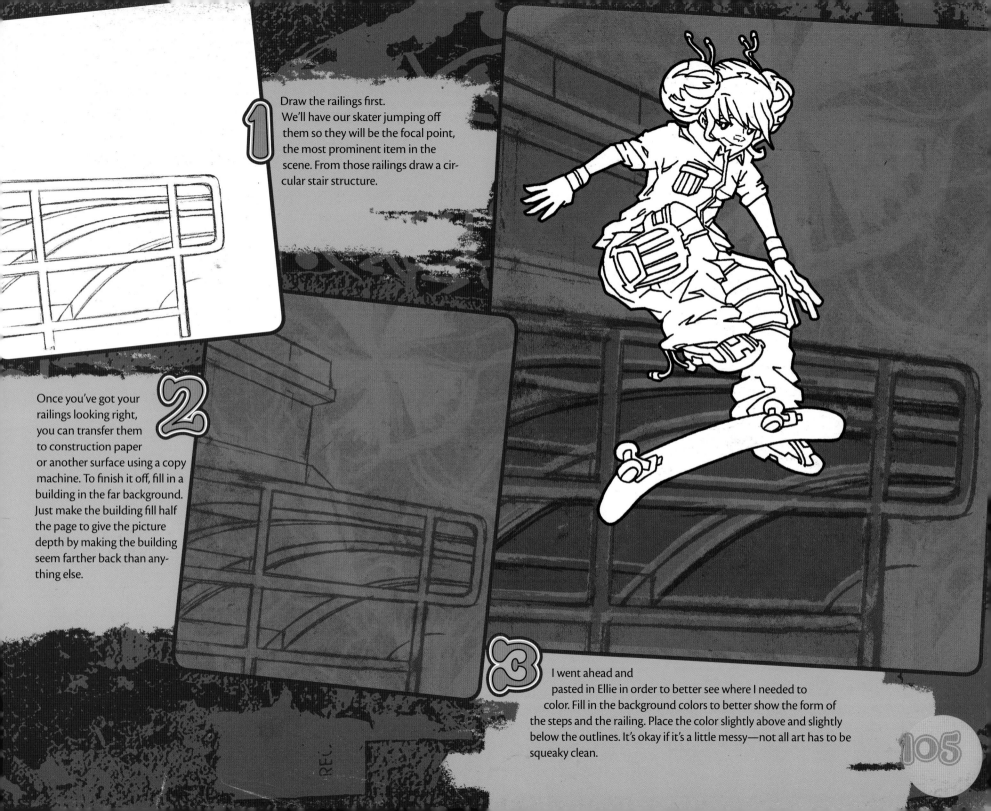

1 Draw the railings first. We'll have our skater jumping off them so they will be the focal point, the most prominent item in the scene. From those railings draw a circular stair structure.

2 Once you've got your railings looking right, you can transfer them to construction paper or another surface using a copy machine. To finish it off, fill in a building in the far background. Just make the building fill half the page to give the picture depth by making the building seem farther back than anything else.

3 I went ahead and pasted in Ellie in order to better see where I needed to color. Fill in the background colors to better show the form of the steps and the railing. Place the color slightly above and slightly below the outlines. It's okay if it's a little messy—not all art has to be squeaky clean.

105

Snowboarder Background 1

We'll stick to the simplest colors and shapes for this background.

For this scene, I colored only the most important elements: my snowboarder, Beulah, the middle ice formation and the billowing wind. For Beulah, I just followed the color scheme from page 78. For the ice, I used white, light gray and dark gray within the divisions. I just colored around the outside of the wind to keep it airy.

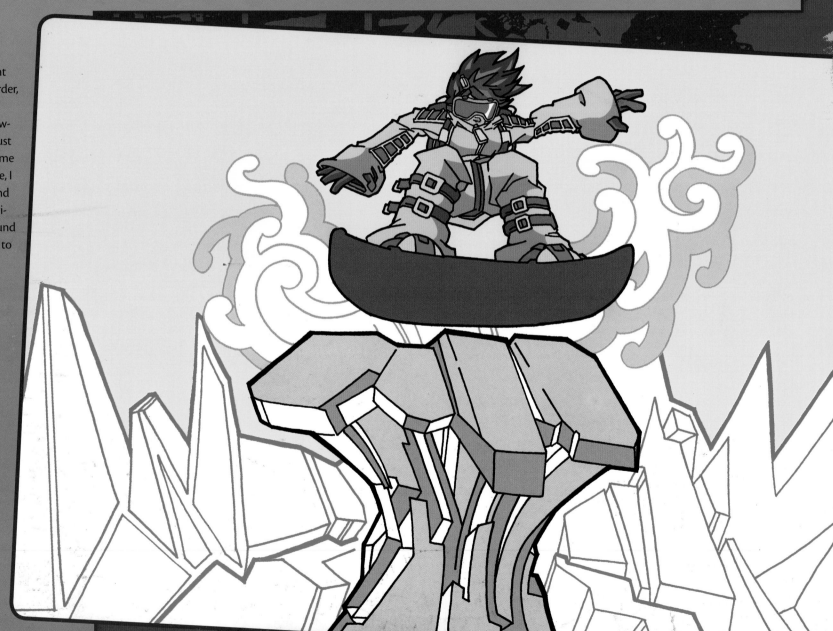

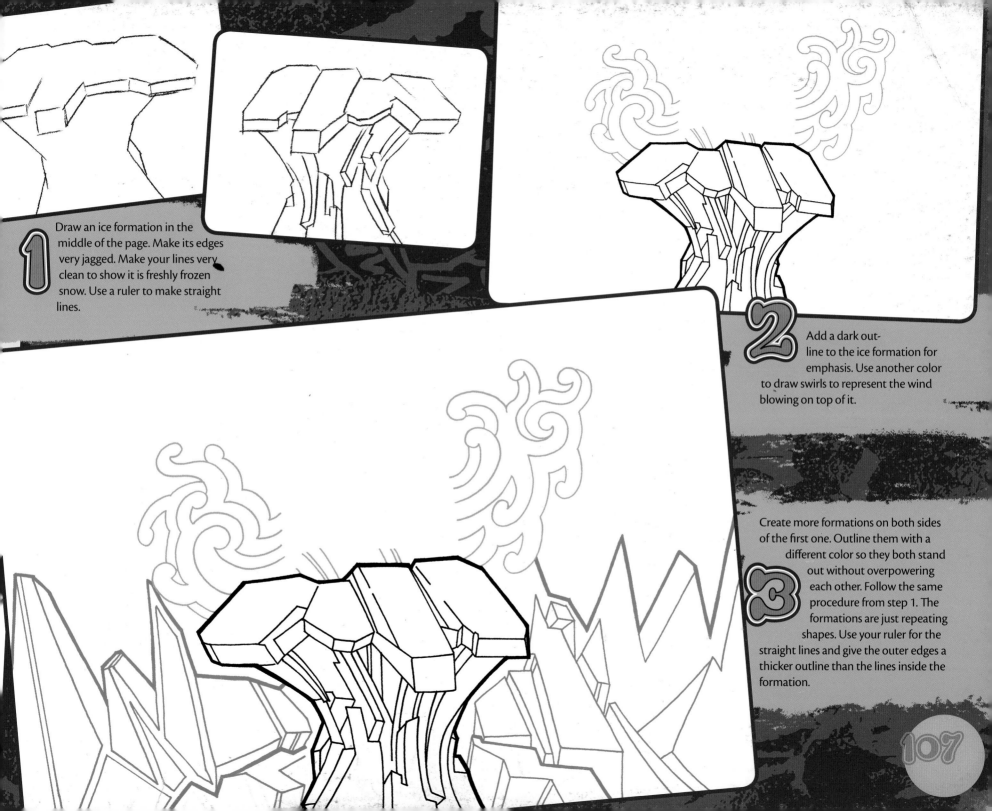

1 Draw an ice formation in the middle of the page. Make its edges very jagged. Make your lines very clean to show it is freshly frozen snow. Use a ruler to make straight lines.

2 Add a dark outline to the ice formation for emphasis. Use another color to draw swirls to represent the wind blowing on top of it.

3 Create more formations on both sides of the first one. Outline them with a different color so they both stand out without overpowering each other. Follow the same procedure from step 1. The formations are just repeating shapes. Use your ruler for the straight lines and give the outer edges a thicker outline than the lines inside the formation.

Snowboarder Background II

Keep that ruler handy—you'll need it for several of the lines in this illustration, too.

I wanted to keep a limited palette for this background to convey a rather solitary mood. The brightest colors here are in between the little energy lines coming from Dixon, our snowboarder.

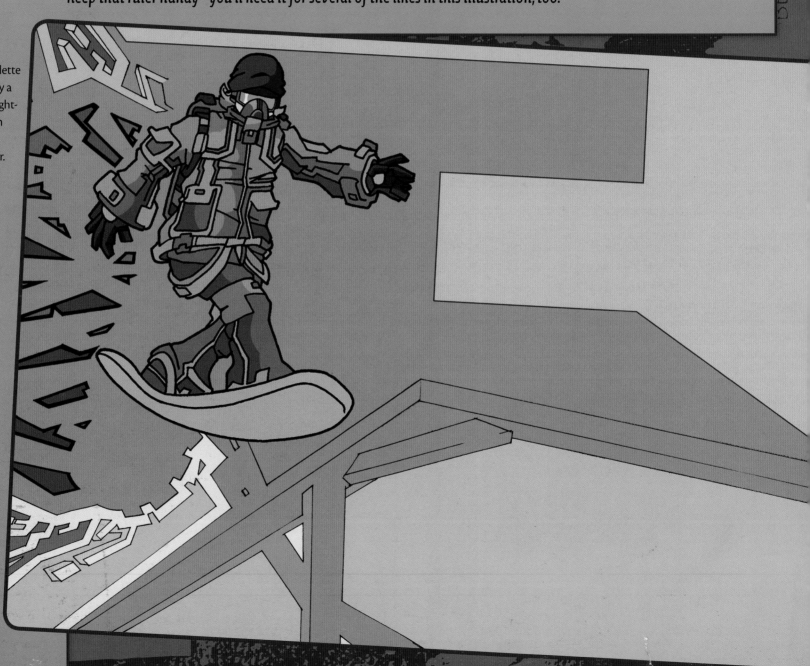

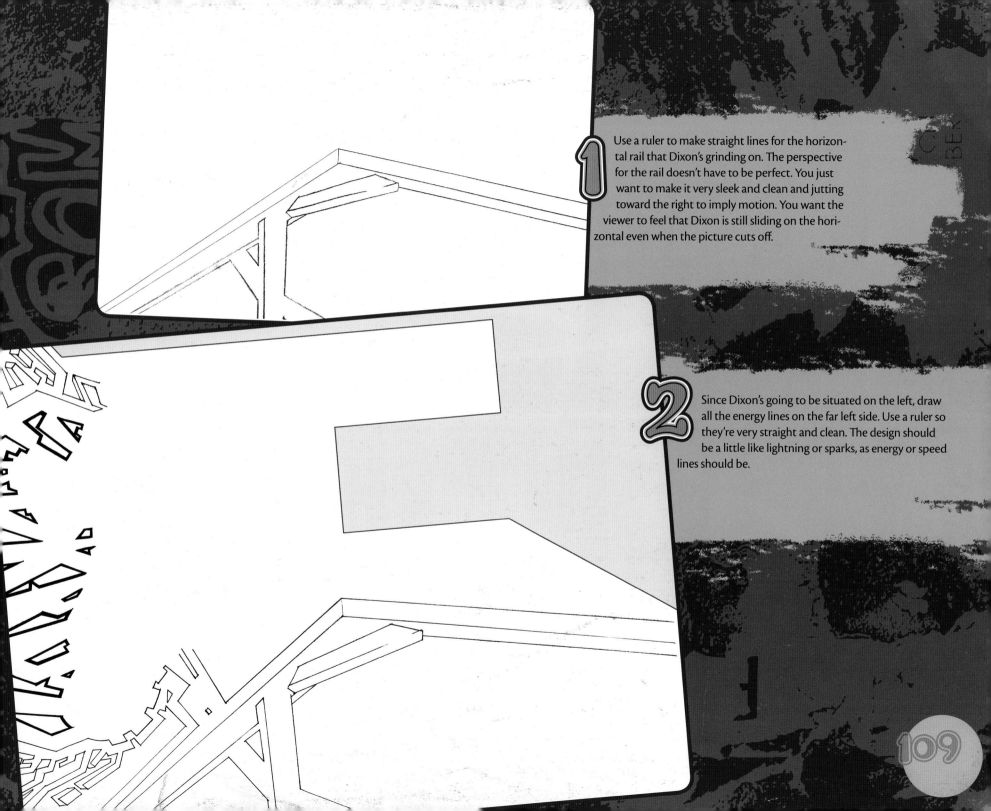

1 Use a ruler to make straight lines for the horizontal rail that Dixon's grinding on. The perspective for the rail doesn't have to be perfect. You just want to make it very sleek and clean and jutting toward the right to imply motion. You want the viewer to feel that Dixon is still sliding on the horizontal even when the picture cuts off.

2 Since Dixon's going to be situated on the left, draw all the energy lines on the far left side. Use a ruler so they're very straight and clean. The design should be a little like lightning or sparks, as energy or speed lines should be.

Basketball Scene

Sometimes you can take the color out of your background completely.

I lined up the poses to show that it is one guy performing these actions and not three separate players. The vivid colors of Khalil's uniform really help him pop out from the background.

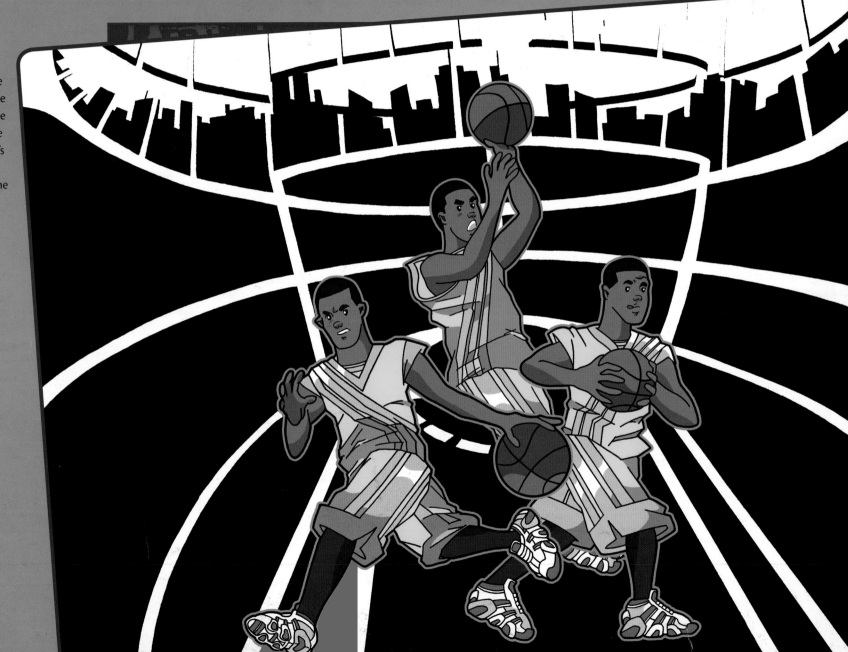

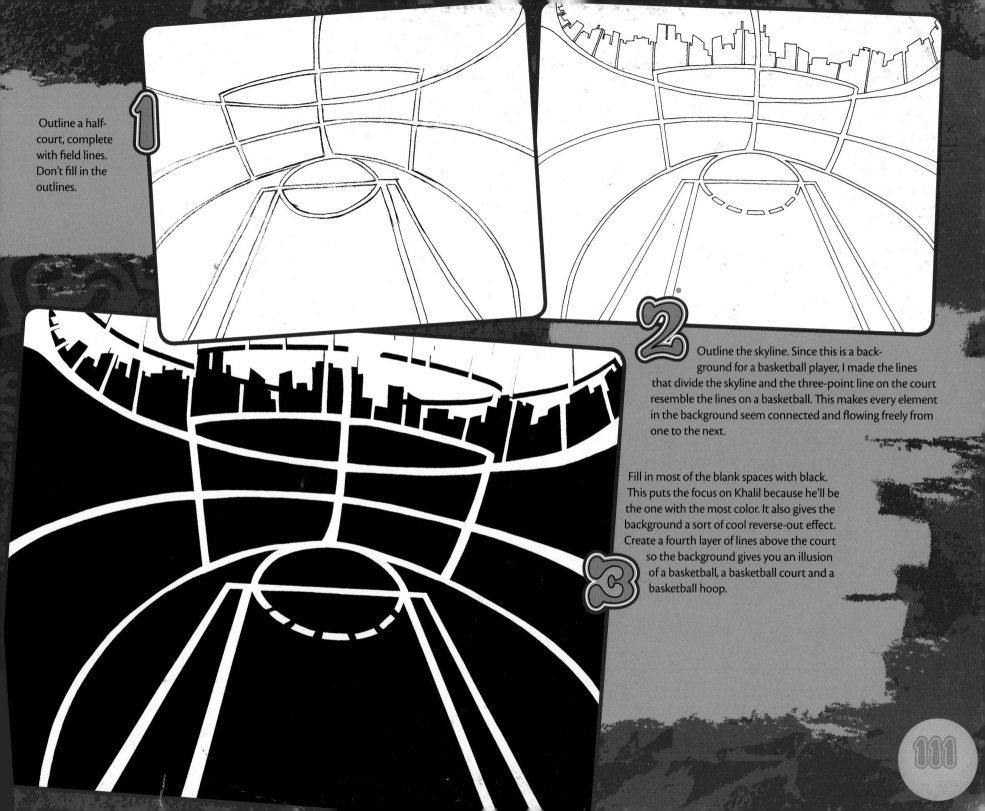

1 Outline a half-court, complete with field lines. Don't fill in the outlines.

2 Outline the skyline. Since this is a background for a basketball player, I made the lines that divide the skyline and the three-point line on the court resemble the lines on a basketball. This makes every element in the background seem connected and flowing freely from one to the next.

3 Fill in most of the blank spaces with black. This puts the focus on Khalil because he'll be the one with the most color. It also gives the background a sort of cool reverse-out effect. Create a fourth layer of lines above the court so the background gives you an illusion of a basketball, a basketball court and a basketball hoop.

DJ Background 1

DJs, by their very nature, are sure to be found in cluttered settings.

I lightly colored the wires around Van to show that they are flowing with energy from all the music. The simple circle in the area that Van is sitting grounds him and keeps him from looking like he's floating.

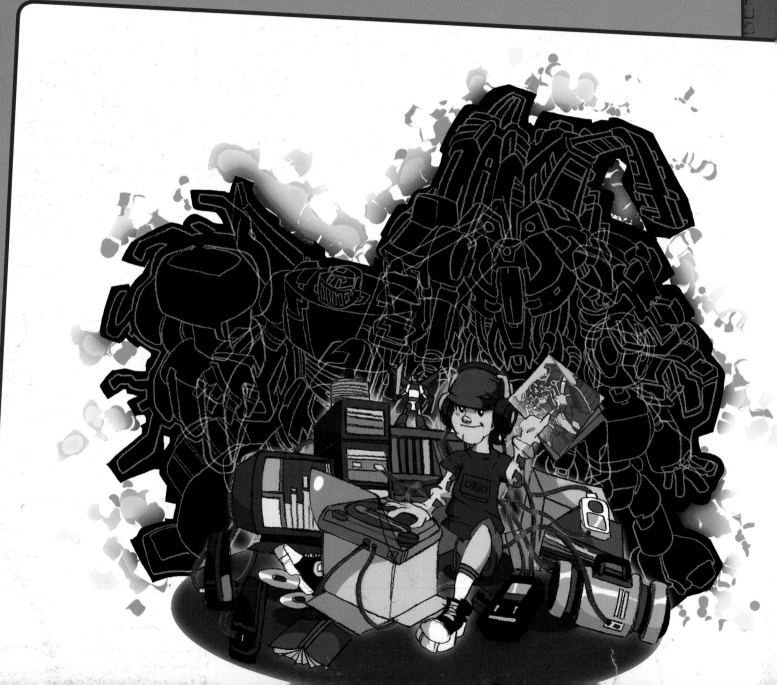

1

Begin with the drawing of Van and his stuff. You'll create the backgound around that. Use a black colored pencil or marker to color in a big area of black space behind him. We'll fill up that space with outlines of robots in the next step. Create several irregular shapes so you can add more fun-looking robots that fit into that space.

2

On a separate sheet, begin working out the robot design. Don't line up the robots side by side; make them all different sizes and shapes, overlapping them to mirror all the clutter.

3

You don't have to draw all the robots on your first try. Work out all the designs before putting them on paper because it will save you time and hassle and erasing. After you've finished all the basic shapes, start adding details such as wires, eyes, claws, etc. Since they're so close together, they'll naturally start to resemble more of a design than individual robots.

4

Use a yellow colored pencil or marker to draw all the robots within the black space using simple lines. Work to fill up all the empty space. Some of the black wires will blend in with the background, but that's okay because you can color them in later. The light color will give an X-ray or radioactive look to the robots.

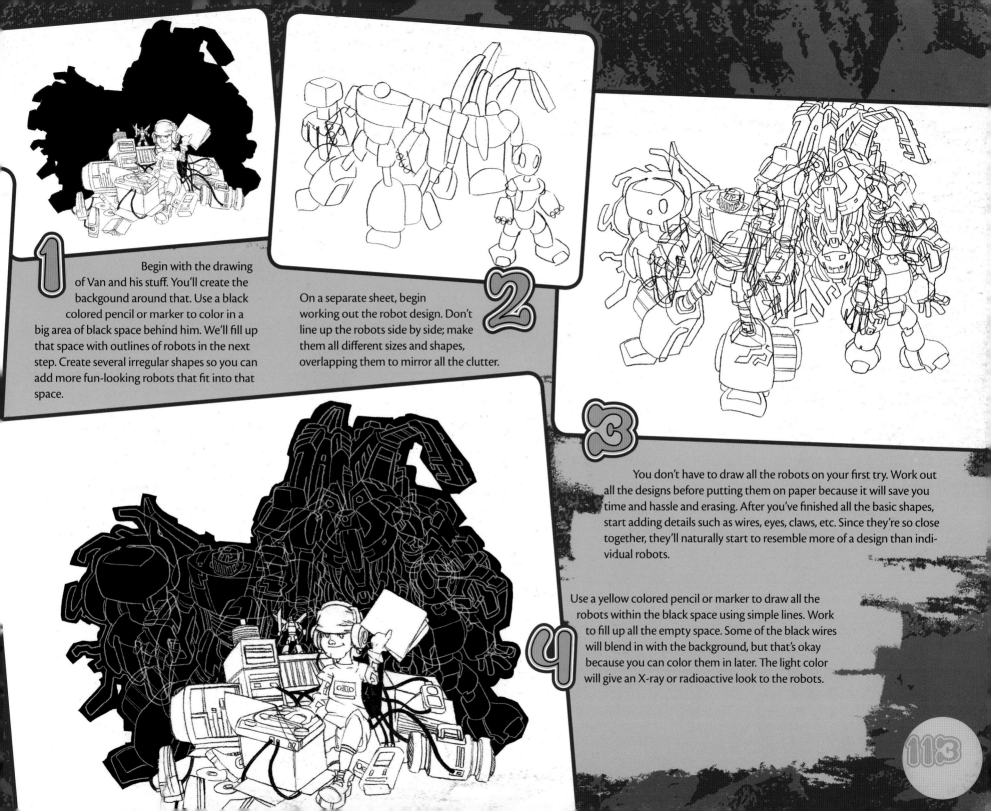

DJ Background II

If Van's background was more literal, with all the wires and things, I went for something a little more abstract for Jen. The idea is that while in front of her turntables, everything else just melts away.

All the shapes and energy are emanating from Jen and her music in the middle.

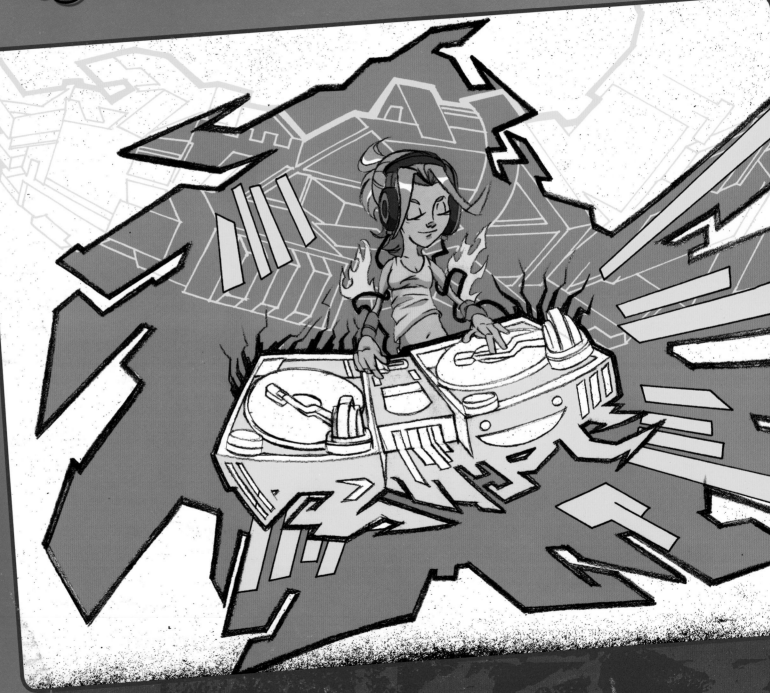

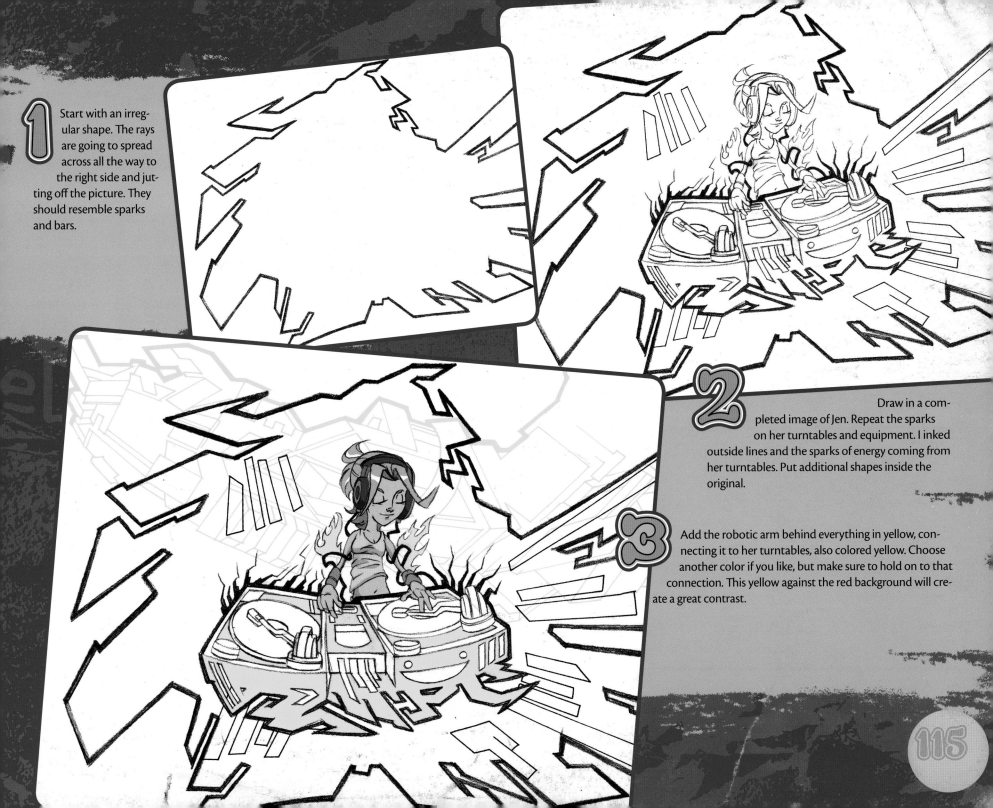

1 Start with an irregular shape. The rays are going to spread across all the way to the right side and jutting off the picture. They should resemble sparks and bars.

2 Draw in a completed image of Jen. Repeat the sparks on her turntables and equipment. I inked outside lines and the sparks of energy coming from her turntables. Put additional shapes inside the original.

3 Add the robotic arm behind everything in yellow, connecting it to her turntables, also colored yellow. Choose another color if you like, but make sure to hold on to that connection. This yellow against the red background will create a great contrast.

115

A graffiti artist will necessarily have a very stylized background.

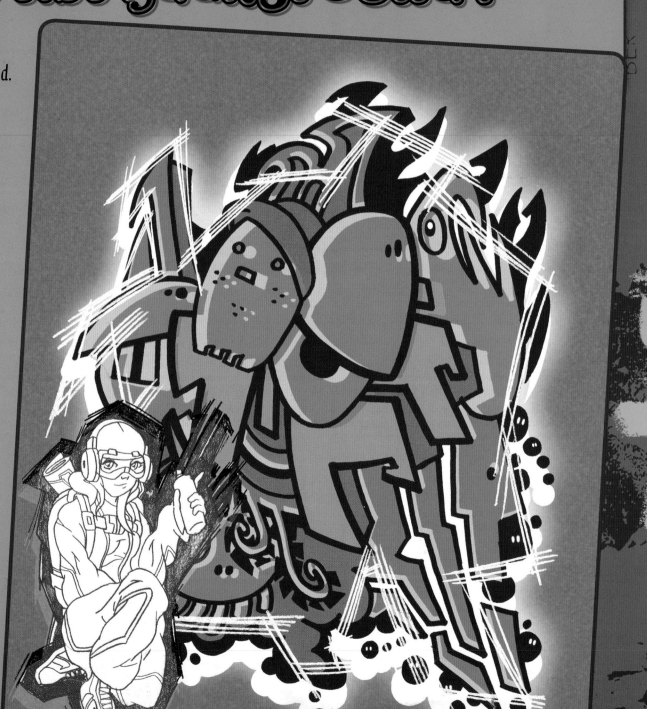

1 Copy or trace this drawing of Tiff crouching down. Shade the area around her with black.

2 On a separate sheet, begin blocking in the piece that Tiff is working on. Just focus on the main shapes—circles that will turn into goofy heads and the scratchy design.

3 Keep playing with the graffiti elements until you get something you like. To finish up the drawing before adding color, add heavy ink lines to define shapes and add shading. Transfer the drawing to include Tiff in the picture and apply color to the shapes and background however you like, remembering to stick to a palette of four or five colors at most.

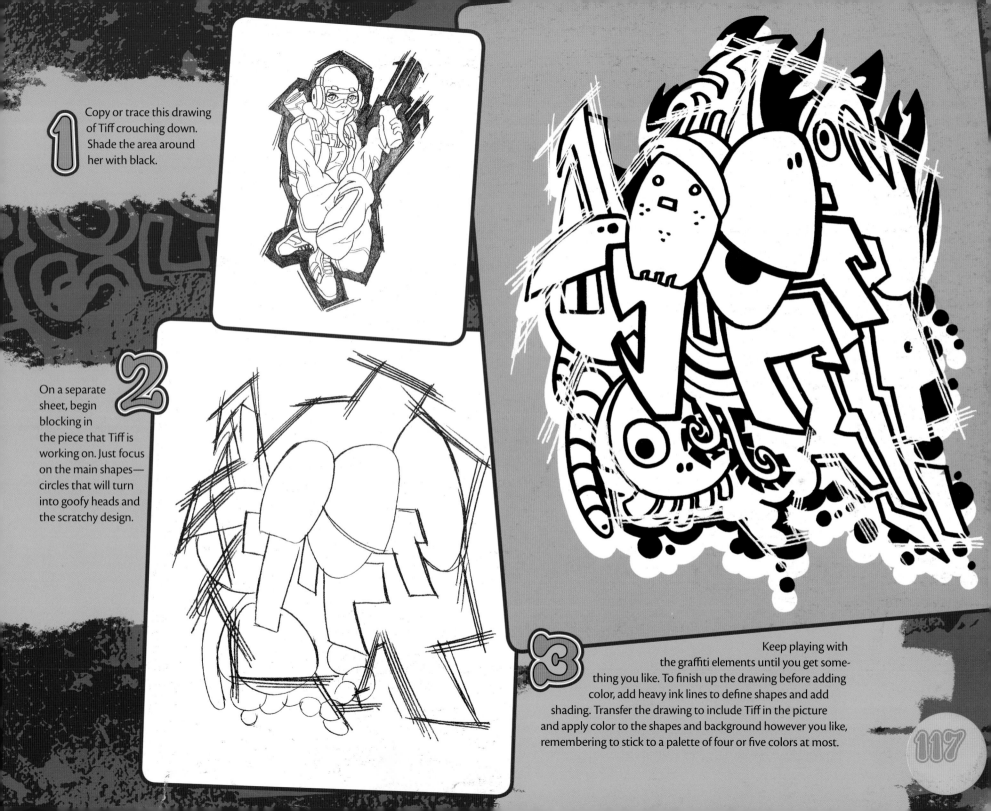

Grafhti Artist Background II

This background is similar to the one you did for Khalil, the basketball player, on page 110.

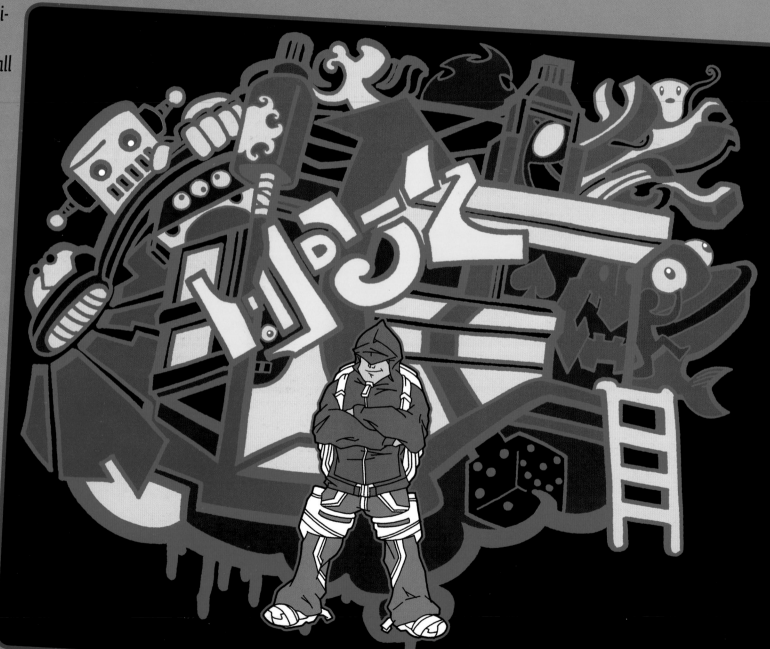

1 The main part of the piece is the structure in the middle. All the other crazy objects will sprout from it. Draw the main part as a series of simple shapes. Skew it to the side a little for interest.

2 Build out from your start point. Add crazy characters, the robot spouting from the top left, arrows emanating from inside the building—the possibilities are endless. Finally, add HP3Z's name to the center.

3 To make everything blue you can either transfer the drawing to another sheet of paper or trace over what you have using blue ink or marker, cleaning up lines in the process. Add finishing touches to the drawing such as the drip spots at the bottom, little eyes here and there and smiling dots on the dice. Add HP3Z to the middle of the piece and your base drawing is finished!

Guitarist Background

You've done a lot of elaborate backgrounds at this point. Here, you'll create a background that evolves from the character.

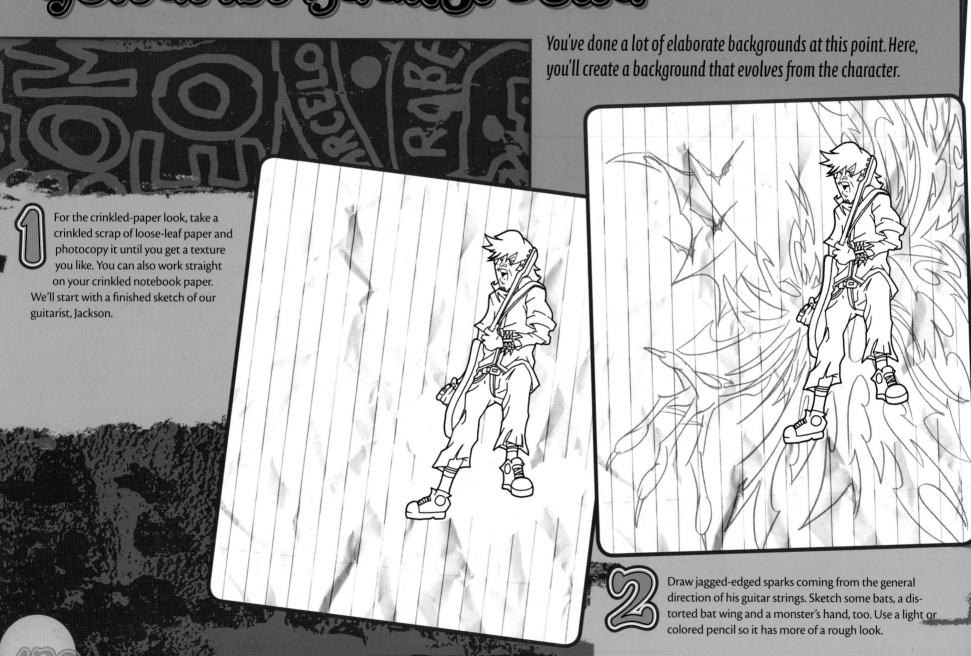

1 For the crinkled-paper look, take a crinkled scrap of loose-leaf paper and photocopy it until you get a texture you like. You can also work straight on your crinkled notebook paper. We'll start with a finished sketch of our guitarist, Jackson.

2 Draw jagged-edged sparks coming from the general direction of his guitar strings. Sketch some bats, a distorted bat wing and a monster's hand, too. Use a light or colored pencil so it has more of a rough look.

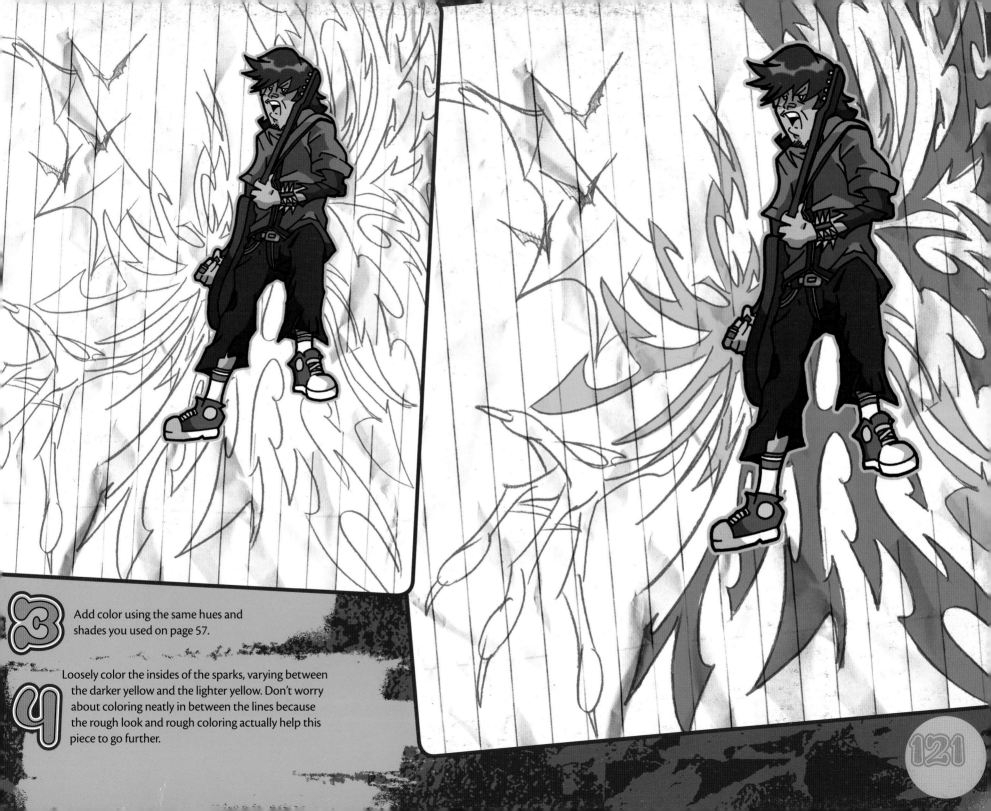

Add color using the same hues and shades you used on page 57.

Loosely color the insides of the sparks, varying between the darker yellow and the lighter yellow. Don't worry about coloring neatly in between the lines because the rough look and rough coloring actually help this piece to go further.

121

CONCLUSION

Most of the pieces in this book reflect my style, which is something that has developed over time from many other styles. By practicing the different projects, I hope it helps you develop a style that is completely yours.

With anything you enjoy doing, it's important to keep learning and practicing to keep your mind and spirit fresh. Without constant learning, you run the risk of hitting a wall in your development. You may only achieve a fraction of what you could have with constant practice.

Your sketchbook is where many of your ideas will come from. Draw whatever comes into your mind—and who knows—maybe you will come across something you really like. Your sketchbook shouldn't be filled with perfect pictures; it should instead be filled with ideas. Draw aimlessly, with no restrictions…save the perfect pictures for someplace else.

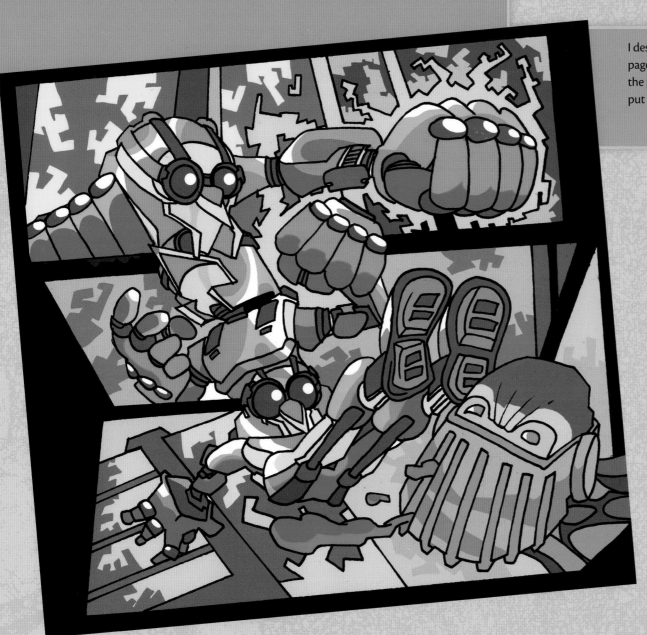

I designed this to play on the idea of a comic book page—except here the hero is literally busting through the panels as he chases the villain. Take something old and put your own unique spin on it.

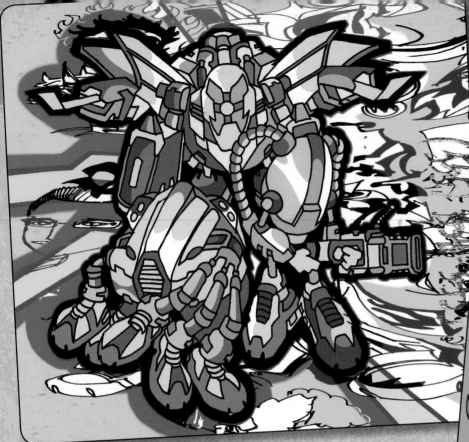

Keep design and detail on robots simple. Then, by simply repeating shapes and colors, you can make something that actually appears complex but isn't.

This picture relies almost completely on geometric shapes. The faces are meant to contrast with these basics. Since the complex colors are limited to only the girls, the color palette works along with this to focus on them.

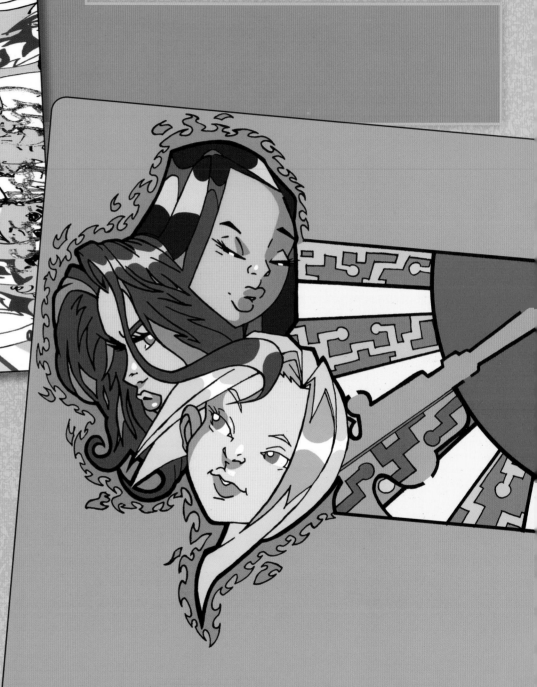

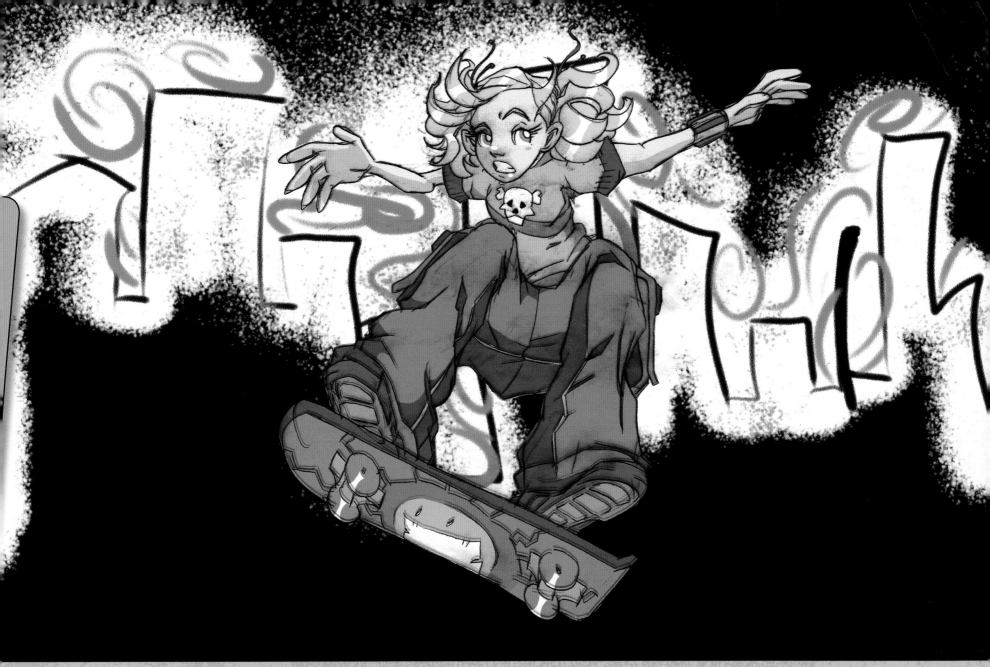

You don't need a lot of complexity to create an effective background. A few lines and some scattered paint effects made a very effective background for this skater. Her fairly elaborate coloring, contrasted with the basic background, makes for a powerful piece.

INDEX

IF YOU'RE GOING TO DRAW, DRAW WITH IMPACT

Discover the fast, fun art of drawing comic portraits! Caricaturist Harry Hamernik shares the secrets to capturing the sillier sides of friends, family, celebrities, strangers—any face that crosses your path.

ISBN-10: 1-58180-759-7, ISBN-13: 978-1-58180-759-2, PAPERBACK, #33426

Let your imagination soar as you bring majestic dragons and other mythical creatures to life using J "NeonDragon" Peffer's easy-to-follow progressive line art demonstrations.

ISBN-13: 978-1-58180-657-1, ISBN-10: 1-58180-657-4, PAPERBACK, #33252

Every professional comic artist uses photo references. To draw a character consistently and convincingly you need a serious reference library. Buddy Scalera's book/CD-ROM set *Comic Artist's Photo Reference: People and Poses* features over 1,000 awesome-quality, color photos created especially for aspiring or professional comic artists.

ISBN-10: 1-58180-758-9, ISBN-13: 978-1-58180-758-5, PAPERBACK WITH CD-ROM, #33425

These and more great IMPACT books are available at your local fine art retailer, bookstore or online supplier. Or visit our website at www.impact-books.com.